Beginning
COLORED
PENCIL

Tips and techniques for learning to draw in colored pencil

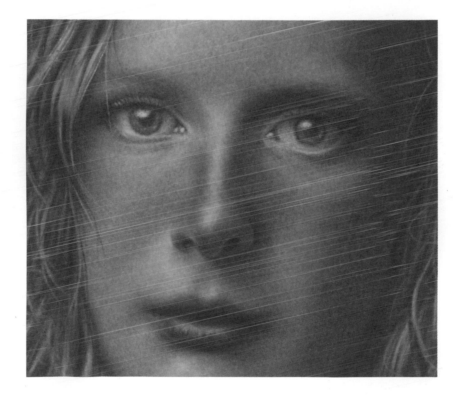

Walter Foster

Brimming with creative inspiration, how-to projects, and useful information to enrich your everyday life, Quarto Knows is a favorite destination for those pursuing their interests and passions. Visit our site and dig deeper with our books into your area of interest: Quarto Creates, Quarto Cooks, Quarto Homes, Quarto Lives, Quarto Drives, Quarto Explores, Quarto Gifts, or Quarto Kids.

First Published in 2017 by Walter Foster Publishing, an imprint of The Quarto Group.
6 Orchard Road, Suite 100, Lake Forest, CA 92630, USA.
T (949) 380-7510 F (949) 380-7575 **www.QuartoKnows.com**

Walter Foster Publishing titles are also available at discount for retail, wholesale, promotional, and bulk purchase. For details, contact the Special Sales Manager by email at specialsales@quarto.com or by mail at The Quarto Group, Attn: Special Sales Manager, 401 Second Avenue North, Suite 310, Minneapolis, MN 55401 USA.

ISBN: 978-1-63322-354-7

Page Layout: Melissa Gerber

Printed in China
10 9 8 7 6 5 4 3 2 1

Table of Contents

Introduction

Colored pencil is an exciting and approachable art medium. It is nontoxic and portable, requires few tools, and can be enjoyed by artists of all ages and skill levels. Perhaps its best attribute is the elegant way in which it straddles the line between drawing and painting.

Today, artists around the world work in colored pencil. The flexibility of this medium allows for a wide range of self-expression, with no two artists working in quite the same way. When worked in multiple layers, colored pencil can appear as rich and vibrant as an oil painting, surprising and delighting the viewer. When applied with quick, bold strokes, it's as fresh as a traditional line drawing.

As we work through this book, I hope to impart on you the world of possibilities that awaits you. I will share many ways to use colored pencils so that you can decide what works best for you and your artistic vision, ensuring optimal results. You will have access to the skills and tools needed to successfully adopt colored pencils and begin to find your own voice. The understanding you acquire here, coupled with a little practice, will put you well on your way toward creating your own colored pencil artwork to share with the world.

Let's get started!

FROM LOOSE AND SKETCHY TO FULLY DEVELOPED, PHOTOREALISTIC "PAINTINGS," YOU CAN ACHIEVE MYRIAD ARTISTIC STYLES THROUGH COLORED PENCIL. YOU ARE ONLY LIMITED BY THE BOUNDARIES OF YOUR OWN IMAGINATION AND YOUR WILLINGNESS TO TRY.

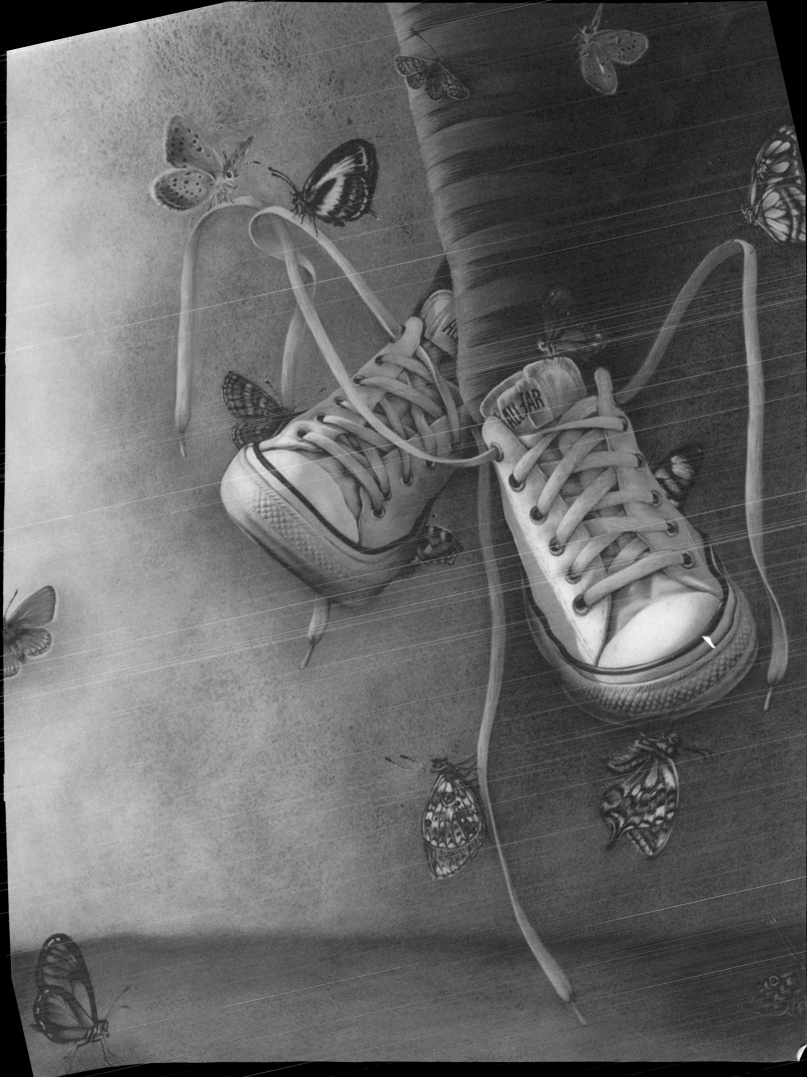

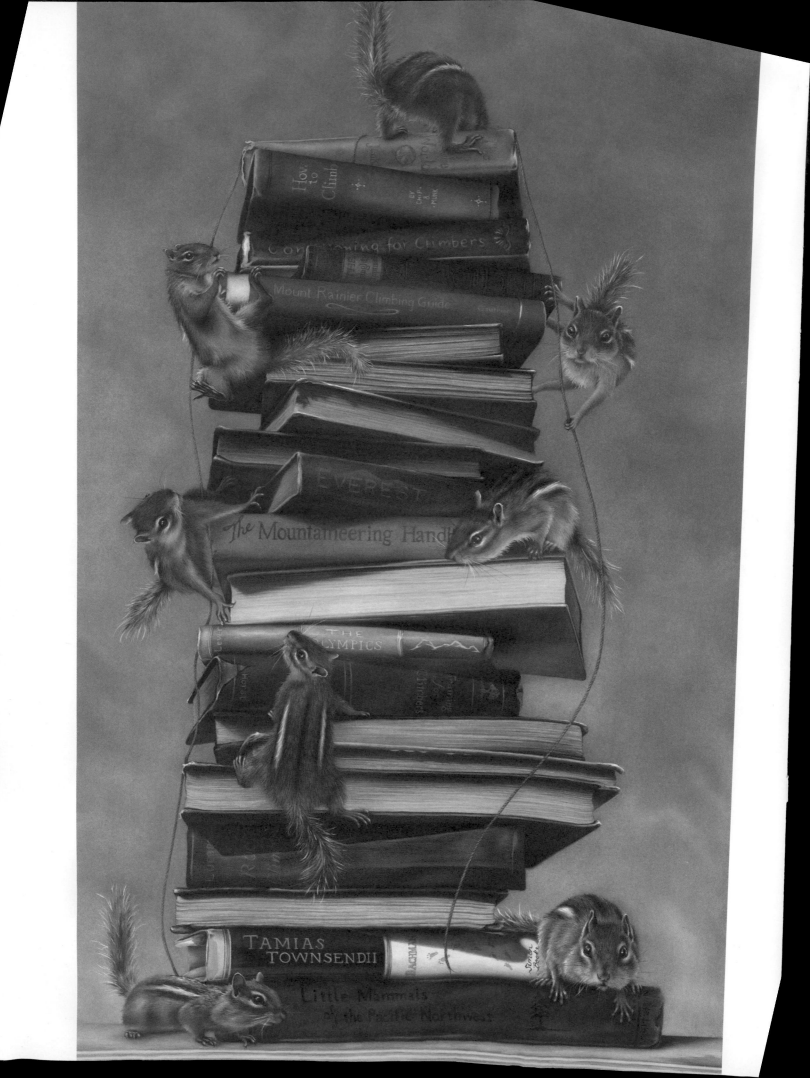

GETTING
Started

Tools & Materials

Drawing with colored pencils requires just a few supplies, and you may already have many of them. As your skills progress, you can choose to add better-quality and more numerous tools to your arsenal. But for now, learn about the simple supplies you'll need to create beautiful, detailed art using colored pencils, and then you can choose what to purchase to get started. The projects in this book list the various colors and supplies that you will need, so you may want to focus on those items first.

SOFT VS. HARD PENCILS

The old saying in oil painting is "fat over lean," and this also applies to colored pencils. Some pencils are harder (leaner), while others are very soft (fatter). There is also a range of degrees in between.

SOFT PENCILS

When layering and blending, it's best to work with softer, more malleable pencils.

tip

LAYERING A HARDER PENCIL OVER SOFTER LAYERS CAN CAUSE INADVERTENT SCRATCHES OR THE REMOVAL OF PREVIOUS LAYERS.

HARD PENCILS

A harder pencil should be used for initial layers and in areas that require no layering at all. Hard pencils contain a different wax-to-pigment ratio, so they sharpen to a finer point and are less prone to crumbling during use. This works well for detail work, lettering, transferring a drawing, and creating a hard edge, but it makes hard pencils less than ideal for blending or filling in large areas of color.

TYPES OF PENCILS

There are three types of colored pencils: wax-based, oil-based, and water-soluble. Purchase a few of each, and experiment with them to see what looks best. Remember that you can always mix and match!

WAX PENCILS

Wax pencils are the most common and softest type of colored pencil. They are made up of color pigment mixed with a wax binder and surrounded by a wooden barrel. Quality and consistency vary by brand, but in general, these pencils have a creamy consistency and layer well.

OIL PENCILS

These pencils are made using an oil binder instead of wax. They tend to be a bit harder, so they are better for creating fine details than for blending, although they can be blended using solvents or heat.

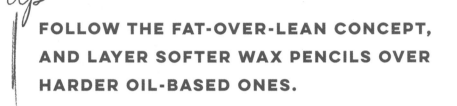

tip

FOLLOW THE FAT-OVER-LEAN CONCEPT, AND LAYER SOFTER WAX PENCILS OVER HARDER OIL-BASED ONES.

WATER-SOLUBLE PENCILS

These pencils contain a water-soluble binder, giving them a watercolor effect. You can apply them dry to paper and then brush over them with water, or try rubbing a water-soluble pencil into a palette, and then apply with a brush. Once dry, layer over water-soluble pencil with wax- or oil-based pencils, but limit the number of layers you apply. Water-soluble pencils work especially well for slightly blurred backgrounds.

tip

USE WATERCOLOR PAPER WITH YOUR WATER-SOLUBLE PENCILS. REGULAR DRAWING PAPER WILL NOT HOLD UP TO WATER.

LIGHTFASTNESS

Like all art mediums, colored pencils are subject to varying degrees of lightfastness, or permanence. The term "lightfastness" refers to a pigment's resistance to change when exposed to light, and it depends on the pigment's chemical nature, the binder used, and its concentration. Using lightfast materials can help determine the life expectancy of your artwork.

If you're a beginning colored pencil artist and wondering which brand to purchase to ensure lightfastness, know that any artist-quality brand will do just fine.

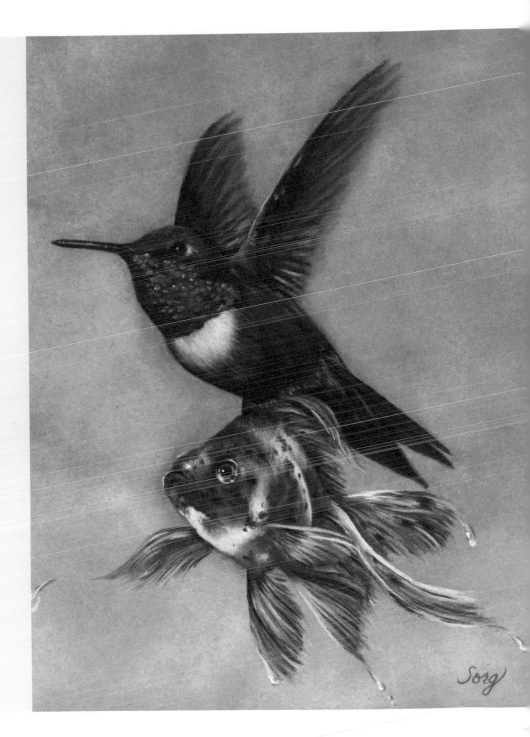

tip

CERTAIN COLORS ARE MORE RESISTANT TO THE EFFECTS OF LIGHT. EARTH COLORS, SUCH AS BROWNS, SIENNAS, AND OCHRES, ARE VERY STABLE, WHILE PINKS, PURPLES, AND REDS ARE MORE PRONE TO FADING.

OTHER ESSENTIAL TOOLS

ERASERS

The efficacy of various erasing tools will vary. Some can remove just a touch of color, allowing only for minor adjustments, while others remove nearly all layers. Try different types—including kneaded erasers, which can be shaped to fit into small areas and reused many times; hard plastic erasers; and typewriter erasers, which can be run through a pencil sharpener to form a fine point and will erase dark colors—to determine your favorite.

tips

LOOK FOR A SHARPENER THAT CREATES A NICE, SHARP, ELONGATED POINT AND THAT FEATURES AN AUTO-STOP FEATURE.

SHARPENERS

Just as you will draw better if you use a sharpened colored pencil, you will also need a tool for keeping it that way. Electric and battery-operated sharpeners, which are easy to use and spin pencils rapidly without splitting or chipping their wood, are the best tools for this job.

BLENDERS

There are two types of blending: wet and dry. We'll go into more detail about them later. For now, remember that wet blending requires the use of solvents, alcohol, or blending markers. In contrast, dry blending is done using colorless blenders (a colored pencil with just wax and no pigment); heat; a stiff, dry brush; or blending stumps (tortillons). Each tool yields a slightly different result, so you will want to familiarize yourself with all of them.

tip

TO CREATE A SHINY BLEND WHILE DRAWING EYES OR METALLIC SURFACES, FOR INSTANCE, USE A BLENDING PENCIL OR A WET TECHNIQUE. FOR A SOFTER, AIRBRUSHED LOOK, SUCH AS FOR CLOUDS OR SKIN, CHOOSE THE DRYBRUSH METHOD OR A STUMP.

PAPER

Choosing the right paper is one of the most important steps toward ensuring drawing success. For a finished-looking, detailed drawing, try paper with very little tooth. Rough paper will hinder any attempts at creating fine lines and detail. For looser drawings or ones with fewer details, a toothier drawing paper or rough watercolor paper are good options.

Look for artist-quality paper of medium to heavy weight to allow for multiple layers of colored pencil. Then feel free to experiment; there are many types of paper to choose from.

tip

USE A STYLUS FOR CREATING FINE LINES LIKE WHISKERS, LETTERING, OR THE RIGGING ON A SAILBOAT.

STYLUS

This tool makes a controlled dent in your drawing paper, which can help keep certain areas clear of any pencil color.

tip

BEFORE USING A FIXATIVE ON YOUR ART, TEST IT ON COLORED PENCIL SWATCHES.

FIXATIVES

Sealing your artwork allows it to be framed without a glass cover, and it also prevents wax bloom. When using wax-based colored pencils, your art may develop wax bloom when the wax oxidizes with the air. This is especially likely if you use a heavy hand and lots of layers, which can cause a slightly hazy look, especially in darker-value areas. However, sealing the drawing with a light layer of fixative can prevent this from occurring.

KEEPING CLEAN

Colored pencils tend to crumble and break off as you work, leaving little bits of color on your paper, which can cause muddiness or dirtiness in your artwork. To prevent this, use a dust brush to keep your drawing clean. Also, remember to wipe off your pencils after sharpening to avoid spreading dust on your drawing. Finally, placing a piece of scratch paper under your drawing hand will help to keep your artwork free from oil and dirt.

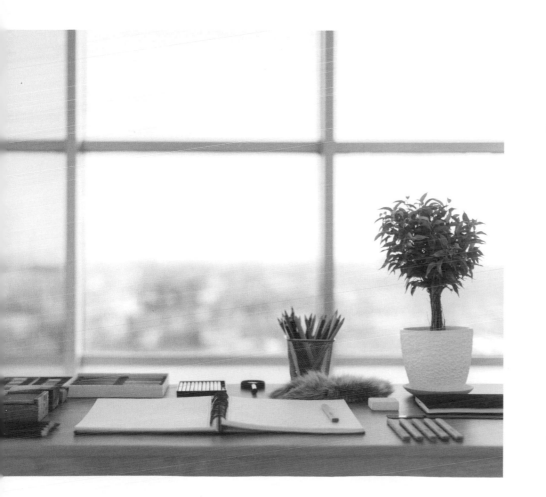

LIGHTING

Consider the lighting when setting up your work area. Select an area featuring as much natural light as possible, as well as balanced lighting that is not too warm (yellow) or too cool (blue). A north-facing window will bring in nice lighting, but a good lamp or two also works well.

Choosing Color

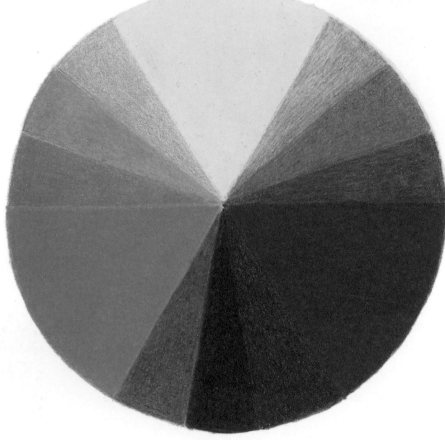

A color wheel is a useful reference tool for understanding color relationships. Knowing where each color lies on the color wheel makes it easier to understand how colors relate to and react with each other.

Colored pencils are transparent by nature, so instead of "mixing" colors as you would in a painting, you create blends by layering colors on top of one another. Knowing a little about basic color theory can help you when drawing with colored pencils.

Primary colors are red, yellow, and blue. These three basic colors can't be created by mixing other colors, and all other colors are derived from them.

Secondary colors are orange, green, and purple. Each is a combination of two primary colors.

Tertiary colors are red-orange, red-purple, yellow-orange, yellow-green, blue-green, and blue-purple. They are combinations of a primary color and a secondary color.

COMPLEMENTARY COLORS

Complementary colors sit directly opposite from each other on the color wheel. Examples are blue/orange, red/green, and yellow/purple. Complementary colors contrast with each other, so they can be used to neutralize each other, or reduce the level of saturation.

WHEN PLACED NEXT TO EACH OTHER, COMPLEMENTARY COLORS CREATE LIVELY, EXCITING CONTRASTS. USING A COMPLEMENTARY COLOR IN THE BACKGROUND WILL MAKE YOUR SUBJECT "POP" OFF THE PAPER.

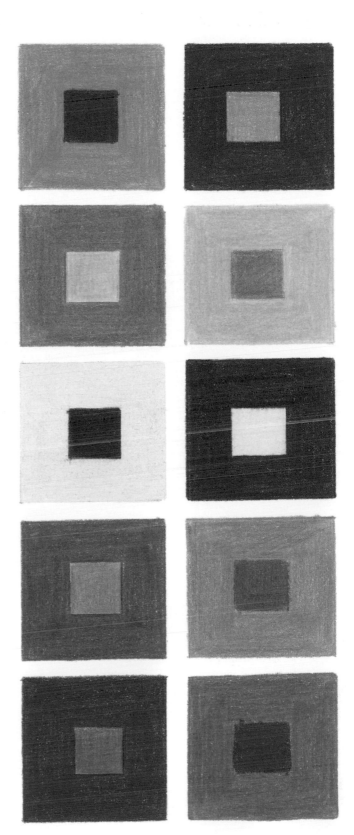

KEY COLOR TERMS

It is important to understand the following terms as they relate to color. Familiarizing yourself with these key concepts and terms will help you effectively use color in your drawings.

LOCAL COLOR

The local color of an object is the color that the brain perceives it to be without the addition of light and shadow. In a strawberry, for instance, the local color is red, but a range of other colors also make up the fruit. These colors are evident because of the way that the ambient light strikes the strawberry's surface and the associated reflections from the items immediately surrounding it.

tip

WHEN DRAWING IN COLOR, START BY DEFINING YOUR SUBJECT'S LOCAL COLOR, AND THEN MOVE OUT FROM THERE TO ALL THE OTHER COLORS THAT ALSO DEFINE THE FORM.

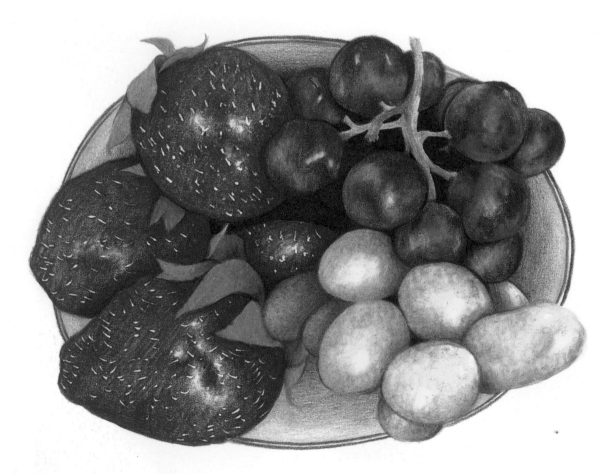

VALUE

Value is the relative lightness or darkness of a color. A gradation of value across a form creates mass and contour, making your subject appear more three-dimensional, whereas contrasting values (i.e., light next to a dark) create a separation between objects.

Value is simple to envision when dealing with black, white, and shades of gray, but it can be trickier to pinpoint when color is thrown into the mix. Because value is so important to the depiction of form, it is worth taking the time to understand it and use it properly.

COOL COLORS GIVE A SENSE OF CALM AND STILLNESS, WHILE WARM COLORS HAVE MORE ENERGY AND MOVEMENT.

TEMPERATURE

Color temperature describes the warmth or coolness of a color in relation to the colors surrounding it. You can use color temperature to convey emotion or mood. The differences in temperature can be very subtle; make a color slightly warmer or cooler than the one next to it, and it will still have an impact.

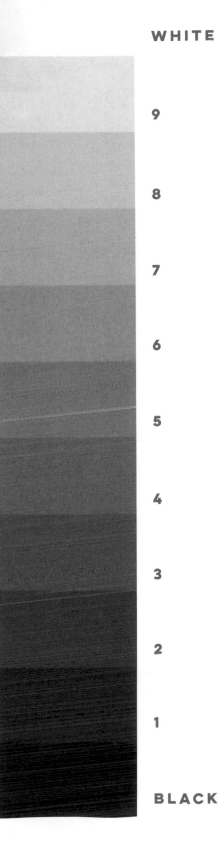

WHITE

9

8

7

6

5

4

3

2

1

BLACK

SATURATION

Saturation describes the degree of purity or intensity of a color. If a color has a higher level of saturation, that means it's brighter, more vivid, and more impactful. A color with a lower saturation is quieter and more neutral.

TINTS, SHADES & TONES

Colors can be tinted with white to make them lighter, shaded with black to make them darker, or toned with gray to make them more muted.

Here each color was applied using graduated pressure—light, then heavy, and then light. Black was applied at the top to tint and tone the colors, respectively.

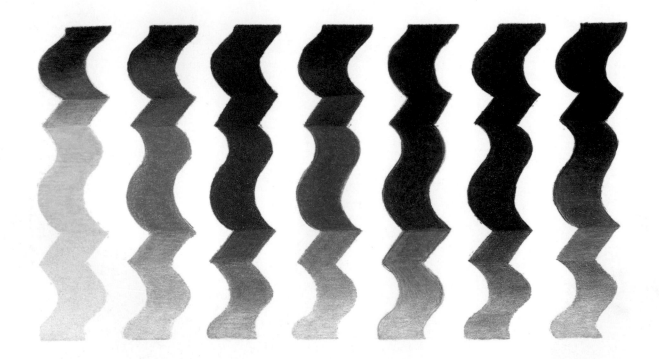

tip

TO TINT A COLOR WITHOUT MUTING IT, APPLY THE WHITE FIRST AND THEN THE COLOR.

PICK A COLOR, ANY COLOR

When it's time to choose the colors with which to render a subject, you will want to keep the following important terms in mind: local color (page 18), temperature (page 19), saturation (page 20), and value (page 19). Of these four concepts, value is the most critical. I find it useful to choose three colors to start with: a middle value, a slightly darker value, and a lighter one.

Create the first layer using your mid-value color. Then consider how the light hits your subject, and begin to apply the other values.

Once you've placed the first three colors in your drawing, you can begin expanding your palette to include reflective colors. These will give your subject life.

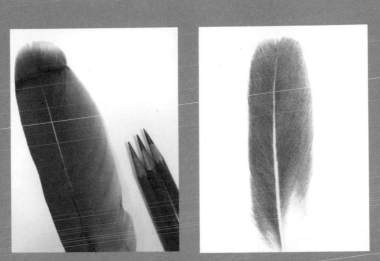

Mid-value

Other values

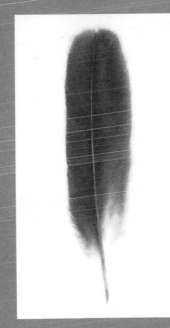

Reflective colors

SELECT SHADES

Colored pencils are mixed on paper, so it helps to have a wide variety of colors to choose from. Depending on the subjects that you most like to draw, your palette will likely include more of certain hues than others. Purchase open-stock pencils in the colors that you use most often so that you don't run out.

Setting Yourself Up for Success

Good drawing begins with the proper setup. Here are some things to keep in mind as you get started.

PERFECT POSTURE

Rather than working on a flat surface, work on a canted drafting table, or raise your drawing at an angle. If you can use an easel, that's even better.

Working on a flat surface makes it difficult to look straight at your drawing. To compensate for this, you may find yourself hunching over your work and placing undue strain on your back, neck, and shoulders.

Instead, crank your drafting table to about 45 degrees (or more), or roll up a towel and place it under the top edge of your drawing hardboard.

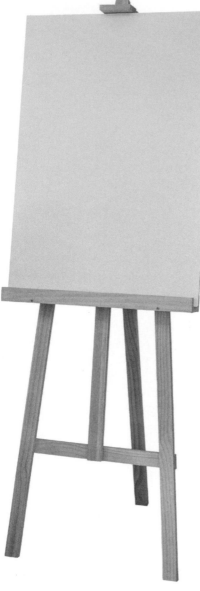

tip

TO KEEP YOUR TOOLS IN PLACE ON A SLANTED SURFACE, LAY A BIT OF RUG UNDERLAY OVER YOUR WORK SURFACE AND/ OR ADD A LIP TO THE BOTTOM EDGE OF YOUR TABLE.

WARMING UP

Just as you stretch before exercising, make sure you limber up your drawing muscles. On a piece of scratch paper, play with scribbles and lines, change the pressure, and try holding your pencil in different ways.

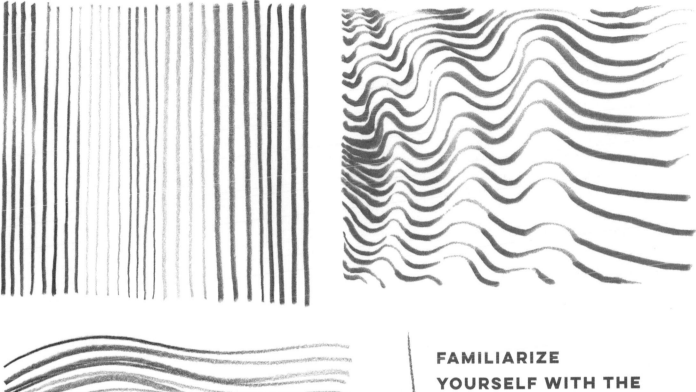

FAMILIARIZE YOURSELF WITH THE DIFFERENT TYPES OF LINES PENCILS CAN CREATE.

HOLDING YOUR PENCILS

How you hold your pencil affects the quality of the line that you create. It's also important, however, that you work in a way that feels physically comfortable without placing strain on your body. For some, holding the pencil in the "normal" or classic way works just fine, and for others it's painful. Your body will tell you what's best.

The angle at which you hold your pencil affects the coverage you get on the paper. If you find that a lot of paper shows through your layers and you would like to reduce that, try holding your pencil in a more vertical position.

HOLDING HOW-TOS

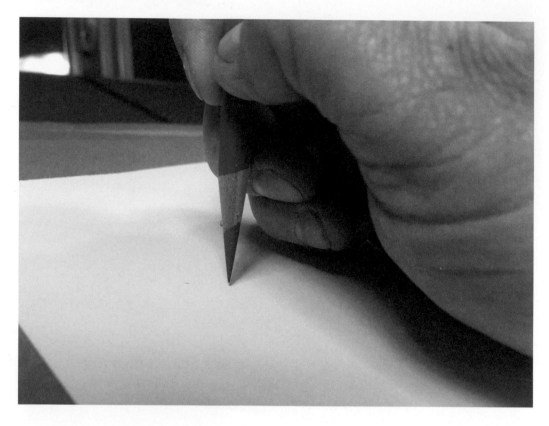

If you hold a sharp pencil in an upright position, it will help you create a smoother layer over the minute hills and valleys that make up the surface of a sheet of paper.

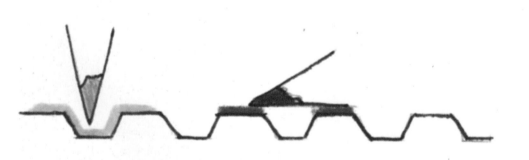

Conversely, a pencil held horizontally will cover the paper quicker but will also show more of the texture on the surface of the paper.

tip

FOR THE MOST CONTROL OVER YOUR PENCIL, HOLD IT THE SAME WAY YOU WRITE.

Even paper that feels smooth has some degree of tooth to it. Experiment with various ways of holding your colored pencils to try out the different effects that you can achieve. Adjusting how you hold the pencil can help you get the type of line you want.

tip

AN OVERHAND GRIP HELPS YOU CREATE STRONG APPLICATIONS OF COLOR WITH HEAVY PRESSURE.

Keep a couple of things in mind during longer drawing sessions so that you remain comfortable.

- Maintain a loose grip on your pencil. Gripping it too tightly can hurt your hand over time.

- Apply the least amount of pressure needed to make the mark you want. The more you push down on the pencil, the tighter your grip will become, adding to muscle tension.

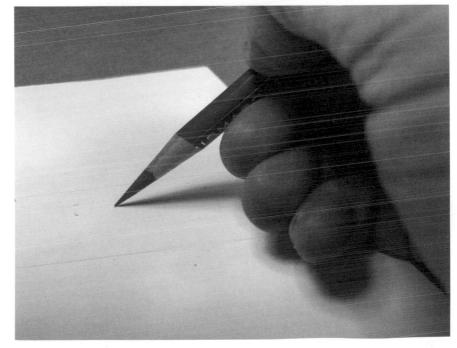

TRANSFERRING A LINE DRAWING

To transfer a line drawing onto a clean sheet of drawing paper, you can use a light box or graphite transfer paper.

Drawing on a separate sheet of paper will keep your final drawing cleaner and allow you to make mistakes, take risks, change your mind and erase, increase or decrease the size of certain items, and cut out parts and move them around until you're happy with your composition. You can work out your entire concept before transferring it onto the final paper. The oils from your hands and erasing can affect a paper's surface, so it's important to keep it as pristine as you can before adding your colored pencil layers.

LIGHT-BOX METHOD

Use a light box for the most controlled and direct method of transfer. Simply tape your prepared line drawing onto the light box's surface, tape your final sheet of paper over the line drawing, and tape that at its top edge. Then use a sharpened sketching pencil to trace the line drawing onto the final paper.

tip

YOU CAN MAKE YOUR OWN LIGHT BOX BY PLACING A LAMP UNDER A GLASS TABLE.

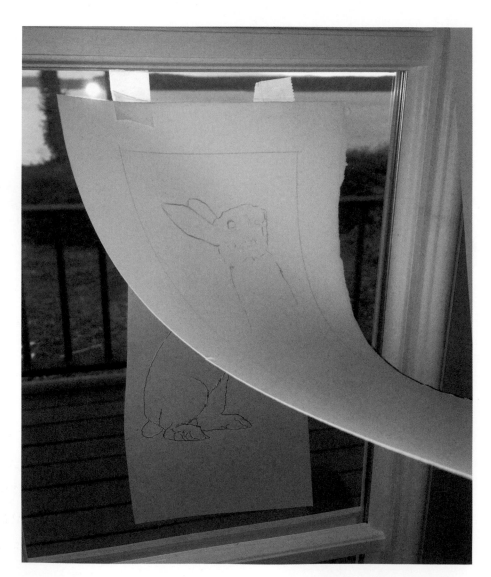

If you don't have a light box, you can use a large window instead.

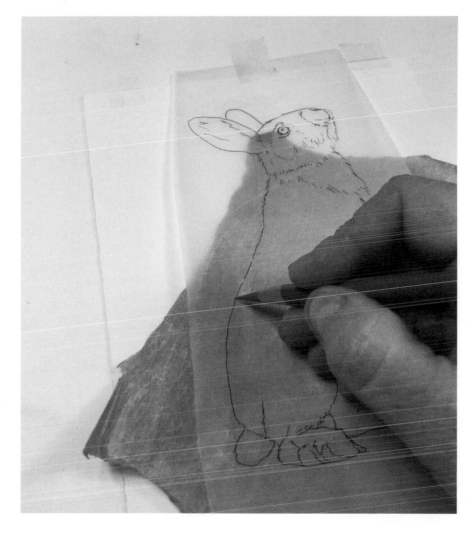

TRANSFER-PAPER METHOD

Carbon or transfer paper can also be used. First, tape your final drawing paper in at least two places to keep it from shifting. Over that, tape the line drawing you wish to transfer along its top edge. Slide a piece of transfer paper between the two with the graphite-coated side facing down. You can now draw over your line drawing and leave marks on your final sheet of paper.

When your drawing is complete, remove the line drawing and transfer paper, and use a kneaded eraser to clean up any bits of graphite or errant marks. Now you're ready to secure your paper to the hardboard backing.

tip

IT'S A GOOD IDEA TO GIVE YOUR PAPER SOME SUPPORT WHILE YOU DRAW. ATTACHING IT TO A PIECE OF LIGHTWEIGHT, HARD, AND INFLEXIBLE BACKING WILL KEEP THE PAPER FROM TEARING, BENDING, OR PUNCTURING WHILE STILL ALLOWING YOU TO MOVE IT AROUND AS YOU WORK.

Basic Colored Pencil Strokes

The sky's the limit when it comes to pencil strokes; there is no wrong way to go. In fact, the more ways you are comfortable laying down color, the better. You might want to convey texture with your strokes, or you could be going for a smooth, airbrushed look without visible strokes. Having the ability and knowledge to choose what type of line will work best is an important tool in your drawing arsenal.

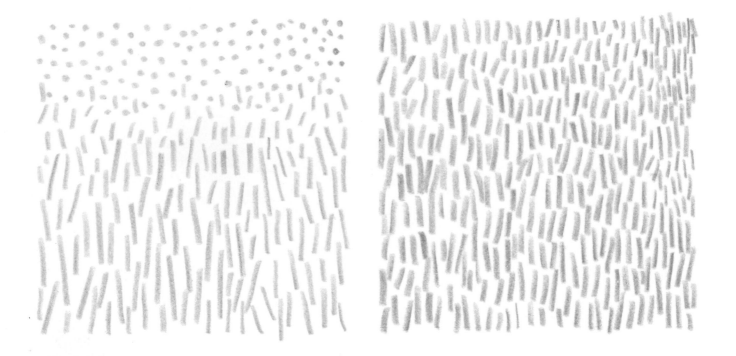

You can imitate a number of different textures by creating patterns of dots and dashes on the paper. To create dense, even dots, twist the points of your pencil on the paper.

PRACTICE MAKING DIFFERENT TYPES OF STROKES.

THE DIRECTION, WIDTH, AND
TEXTURE OF EACH LINE YOU
DRAW WILL CONTRIBUTE TO
THE EFFECTS YOU CREATE.

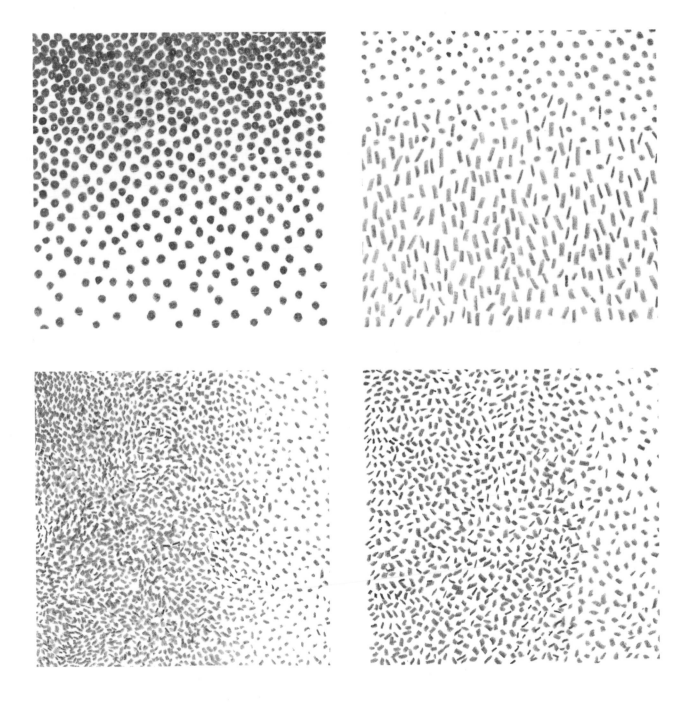

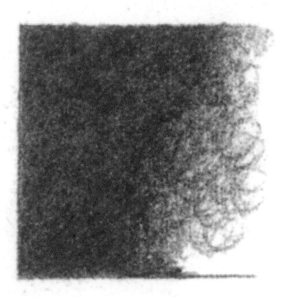

CIRCULAR

The circular stroke is ideal for laying down a smooth, even layer of color. It can be particularly useful for applying base layers of color or for areas that require no texture, such as the sky and skin tones.

LINEAR

Linear strokes can add texture or pattern to a drawing. Placing linear strokes close together minimizes the texture; spacing out the strokes creates a coarser, stronger feel.

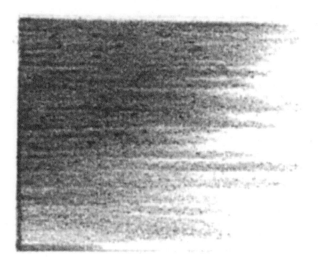

USE LINEAR STROKES WHEN DRAWING WOOD GRAIN OR WEATHERED MATERIAL AND TO CONVEY DIRECTION OR LENGTHEN THE FEEL OF AN OBJECT.

CHANGING THE PRESSURE AND THE AMOUNT OF SCUMBLING YOU DO IN AN AREA CAN INCREASE OR DECREASE THE VALUE OF A COLOR.

SCUMBLING

Applying color via scumbling adds another element of texture to a drawing. Scumbling is random and abstract in nature and can impart a feeling of energy. It can be used to express movement, add excitement, or simply to create texture in subjects like grasses and landscapes.

To scumble, move your pencil at random and in any direction as one long, flowing stroke. Stick to one small area at a time.

CROSSHATCHING

In crosshatching, lines are drawn perpendicularly to each other, creating a darker look where they overlap. Crosshatching requires at least two layers, so the result is a denser, heavier appearance. This stroke can be layered with the same color for a deeper value, or it can comprise multiple colors that will optically mix together on paper.

STIPPLING

Stippling creates a light, airy feel, but it can become dense when dots are applied close together. To stipple, simply tap your pencil up and down like the needle in a sewing machine. You can mix colors through stippling and create an energetic application of color. This stroke is also great for an Impressionistic approach to drawing, as it closely mimics the style that the French painter Georges Seurat made famous.

SCRIBBLING

This delicate stroke allows much of the paper to remain visible. You can increase the intensity of this style by adding multiple layers and/or colors and also by the very colors that you choose to use. Scribbles can be applied alone or over other types of strokes for an added layer of interest and to convey mood.

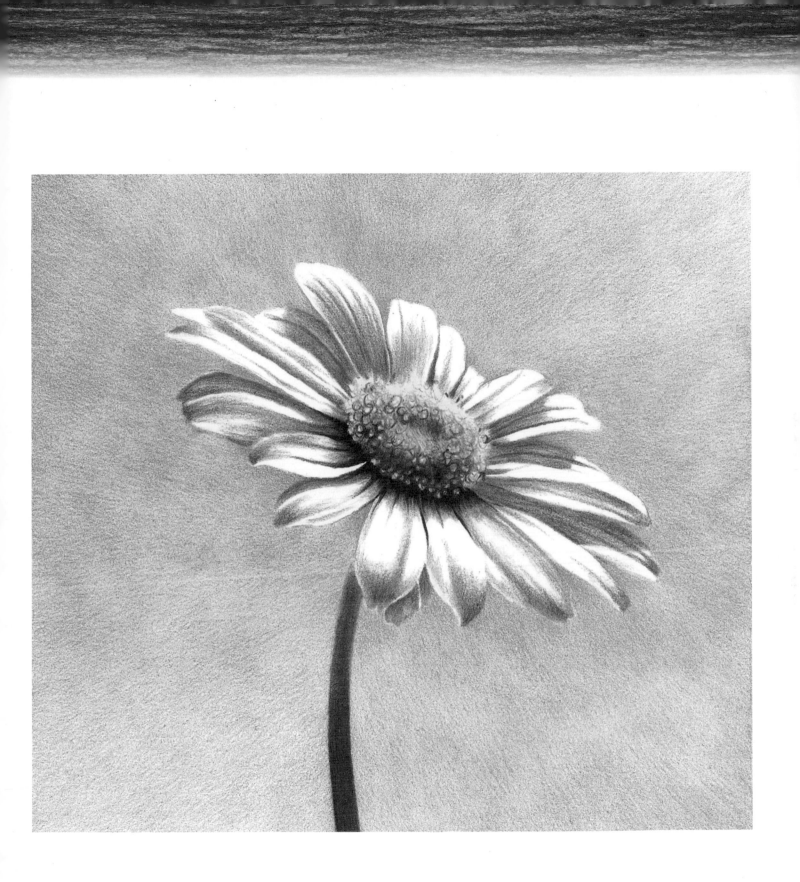

A successful artwork often uses multiple drawing techniques. What do you see here?

Helpful Hints

Follow these tips and suggestions when drawing with colored pencils to ensure success.

CORRECT COLOR ORDER

Unlike with other mediums, when working in colored pencil, you can't add lights after your darker colors are in place. It doesn't work to layer a light-valued colored pencil over a darker-valued one, as the light color won't be very visible.

If you want to keep an area of a drawing white, yellow, or another pale color, you must protect that spot from other colors and leave it the white of the paper until you are ready to put your chosen color in place. Go over this area with a kneaded eraser to clean it before drawing.

I prefer to work from dark to light so that I can do a final cleanup of my light areas just before applying the colors needed to finish a drawing.

ONCE YOU GET THE DRAWING BASICS DOWN, YOU CAN DECIDE WHICH TECHNIQUES TO USE TO CAPTURE YOUR SUBJECT'S UNIQUE QUALITIES.

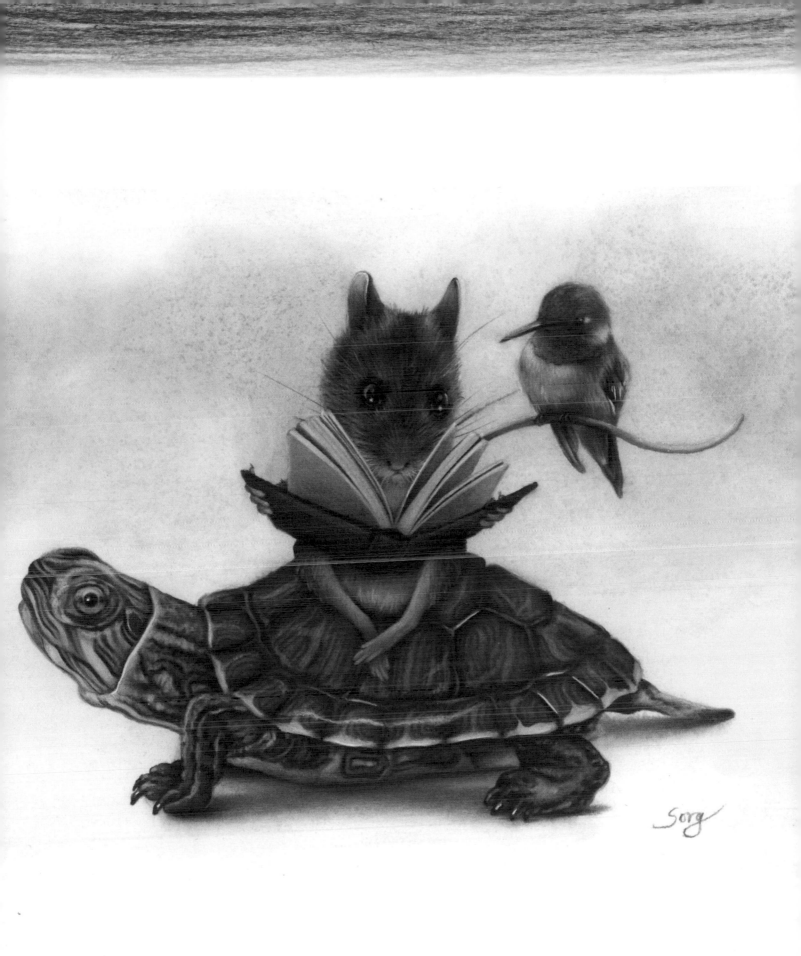

LARGE SHAPES FIRST

First draw your large shapes, and then add any details. Larger, less-complex areas of similar values hold your drawing together and give it strength.

To train your eyes to see these areas, try squinting as you look at your reference photo. This will remove the details and allow you to see just the bigger forms. Eventually, with practice, your eyes will get adept at seeing these shapes and breaking down complex subjects into their simpler components.

Once you've created your initial drawing, continue to keep the underlying shapes in mind as you add your layers of colored pencil. For example, when drawing a cat, you must first establish the anatomy of the animal before drawing the hairs that make up the body.

When this is done thoughtfully and patiently, very little actual detail is needed to finish the drawing and make the cat look "furry." In other words, you don't need to draw every single hair.

tip

LET THE VIEWER'S EYE FILL IN THE DETAILS, AND YOUR DRAWING WON'T APPEAR OVERWORKED.

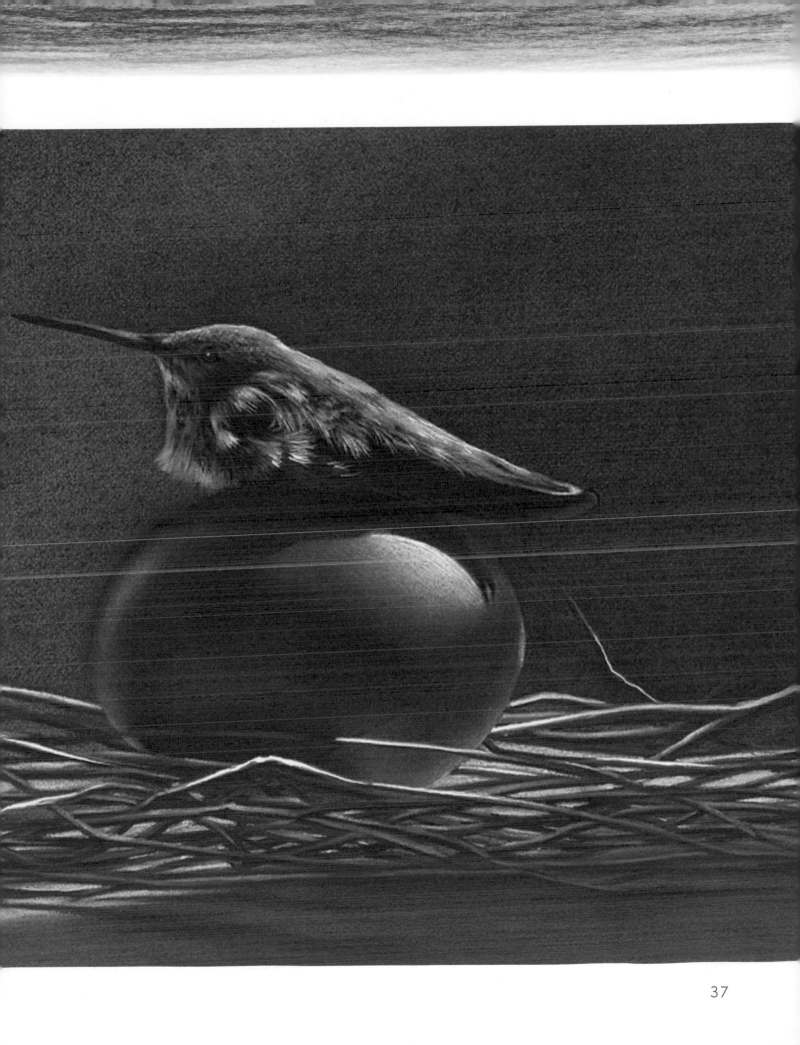

STEP BACK

Colored pencil artists generally don't work on an easel, so it's important to remember to stop, get up, and look at your work from a reasonable distance. Make sure that your values are appropriate and that the drawing looks proportionate.

GIVE IT A FRESH EYE

Colored pencil drawing is many things, but quick is not one of them. You may find yourself spending hours drawing a single area, which can cause you to lose sight of your drawing as a whole. If this occurs, resulting in a drawing that looks a little "off," try the following tricks:

- Give yourself a break. A few hours or days away from your drawing can help you see it in a new light and spot any mistakes.

- Flip it upside down or use a mirror. If you look at a drawing in reverse, the problem area might jump out at you.

WHEN DRAWING A COMPLICATED PATTERN OR AN ABSTRACT FORM, I FIND THAT I WORK MORE EFFECTIVELY IF I DRAW UPSIDE DOWN.

POSITIONS IN SPACE

Just as with painting, when drawing in colored pencil, you should follow certain "rules" to help elements within a drawing appear closer, farther away, or more important.

Generally, an element that is farther away from the viewer will appear cooler, less detailed, and display less contrast than objects that are closer to the viewer's eye. Conversely, subjects that are closer will appear warmer and feature a greater range of values, more detail, and sharper edges.

Our eyes are naturally drawn to brighter colors, higher contrasts, and sharper edges, and utilizing these can draw attention to an element in your drawing. Use this knowledge to manipulate the objects in your drawings and move the viewers' eyes through a composition. These principles will allow you to choose the focal point of a drawing and capture and hold your viewers' attention.

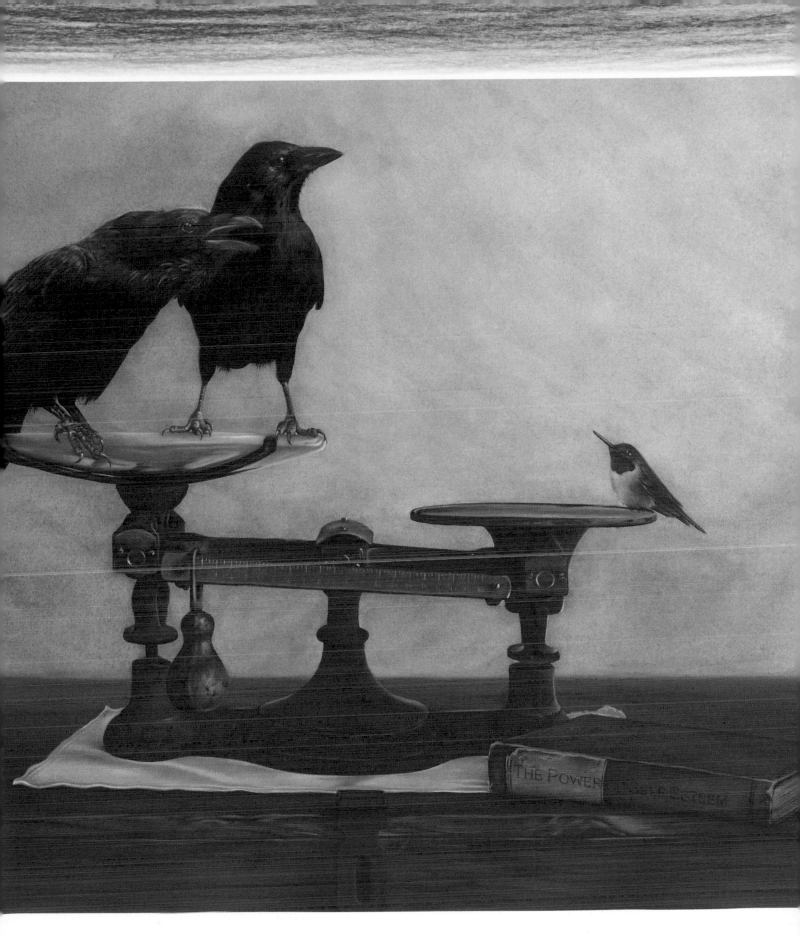

What would you choose as the focal point in this drawing? Why?
How do your eyes move through the drawing?

WORKING FROM PHOTOS

Drawing from life may be preferable, but it's often not possible considering how long colored pencil drawings can take to complete. Photos offer the ideal substitute.

When choosing a reference photo, look for an image with a wide range of contrast and good lighting. A well-lit subject is more compelling, easier to draw, and will appear more lifelike. Photos taken outdoors in natural lighting are usually best.

When working from a reference photo, remember that it is OK, and often better, not to copy the photo too closely. Some elements add nothing to a composition and can be left out, just as replacing certain colors can improve a drawing's impact. Use your eyes and your brain to decide what to include and exclude.

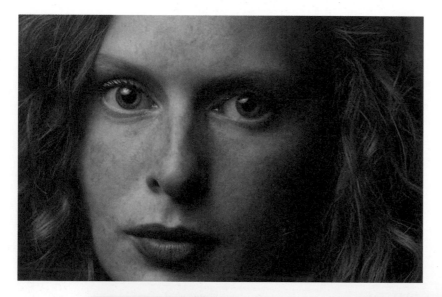

A camera is an invaluable tool for an artist. It saves you from having to work on-site, and it helps you capture a fleeting moment that you can draw later. Remember that you can adapt your reference photo if you wish.

The Care & Feeding of Finished Drawings

Colored-pencil drawings are remarkably durable, but you may want to take a few steps to ensure that yours live a long life after completion.

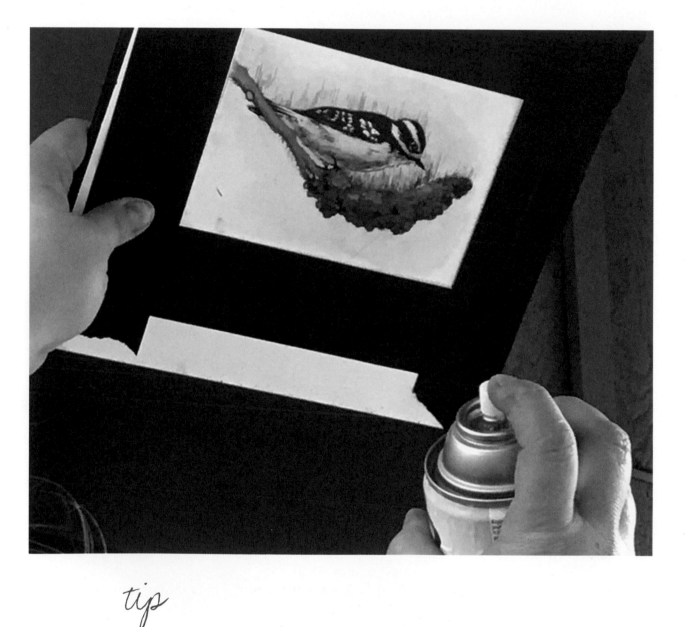

tip

FINISH YOUR DRAWING BEFORE SPRAYING FIXATIVE ON IT, AS IT WILL BE DIFFICULT TO REWORK YOUR ARTWORK AFTERWARD.

TO SPRAY OR NOT TO SPRAY

Many colored-pencil artists choose not to spray a layer of fixative over their finished artwork. For those who add few layers of color or who work with a light hand, fixative may not be necessary.

If, however, you add a lot of wax to your paper and/or use heavy, dark values, spraying with fixative can help prevent wax bloom. (See page 14 to learn about wax bloom.) A single, light layer of fixative is usually sufficient.

A LITTLE BIT OF CARE WILL ENSURE THAT YOUR DRAWING LASTS FOR YEARS TO COME.

FLATTENING

If you notice waves or buckling in your finished artwork, cover it with a clean sheet of paper or tissue paper, and place it facedown on a flat surface. Sponge a bit of water onto the back of your drawing, place hardboard over it, and weigh it down using a heavy item for at least 10 hours. This will flatten your work before you store or frame it.

FRAMING

If you wish to frame your finished colored-pencil art, remember that you will need to keep your drawing paper off the glass. Adding a mat will help, but you can also use plastic spacers.

There are several types of glass that you might choose to use, and each has its own advantages. Regular glass is the least expensive option and works well.

However you choose to frame your masterpiece, always use archival products, and hang your work away from direct sunlight and high humidity.

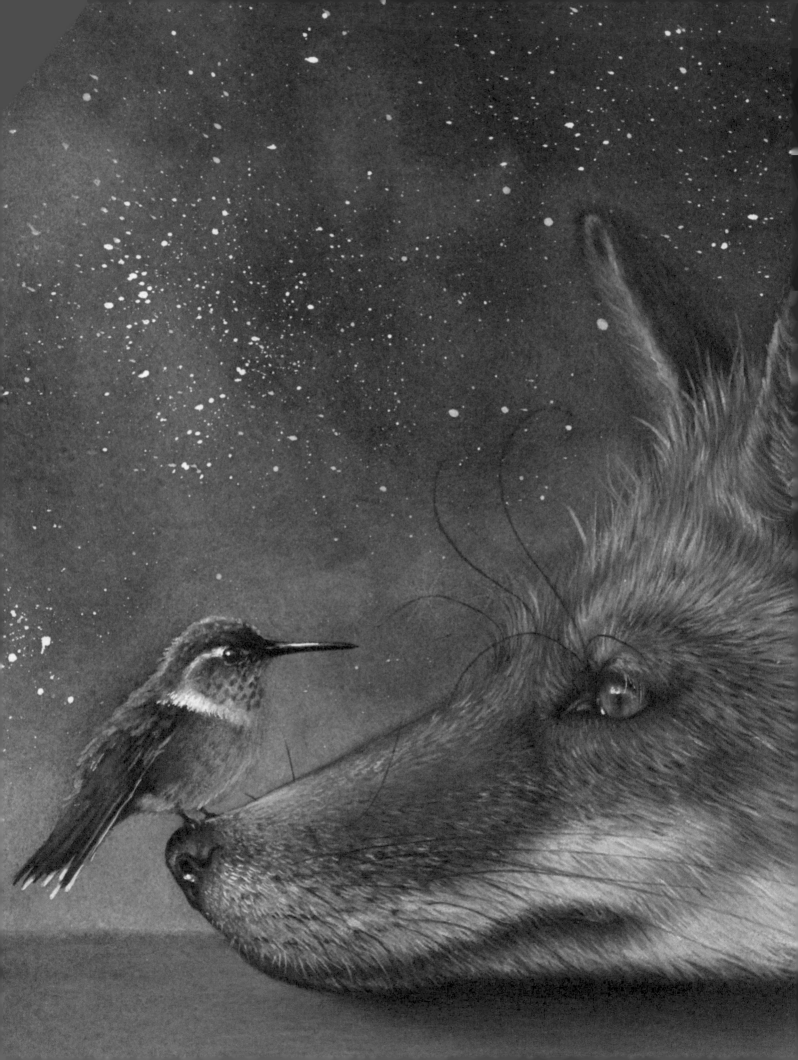

BASIC
Techniques

Layering

One of the primary differences between colored pencils and paint is the importance of layering to achieve your desired color. When working with paint, you can mix and adjust the colors on your palette, but with pencil, the paper is your palette. Think of pencil layering as similar to the glazing process in painting: Add thin veils of color, one on top of the other, until you reach your desired result.

Lightly apply your layers so that they remain transparent and allow the previous layers to show through. Using too much pressure can drown out the previous layers and create a "muddy" color.

How many layers you will need to apply depends on the depth of color you are seeking. Dark, shadowed areas may require many layers, while lighter or more simplified areas of a drawing will need one or two.

WHEN LAYERING, USE LIGHT PRESSURE, WORK WITH A SHARP PENCIL, AND APPLY EACH LAYER SMOOTHLY.

Here, more layers have been added to create a darker value.

For a light valued area, few layers are needed.

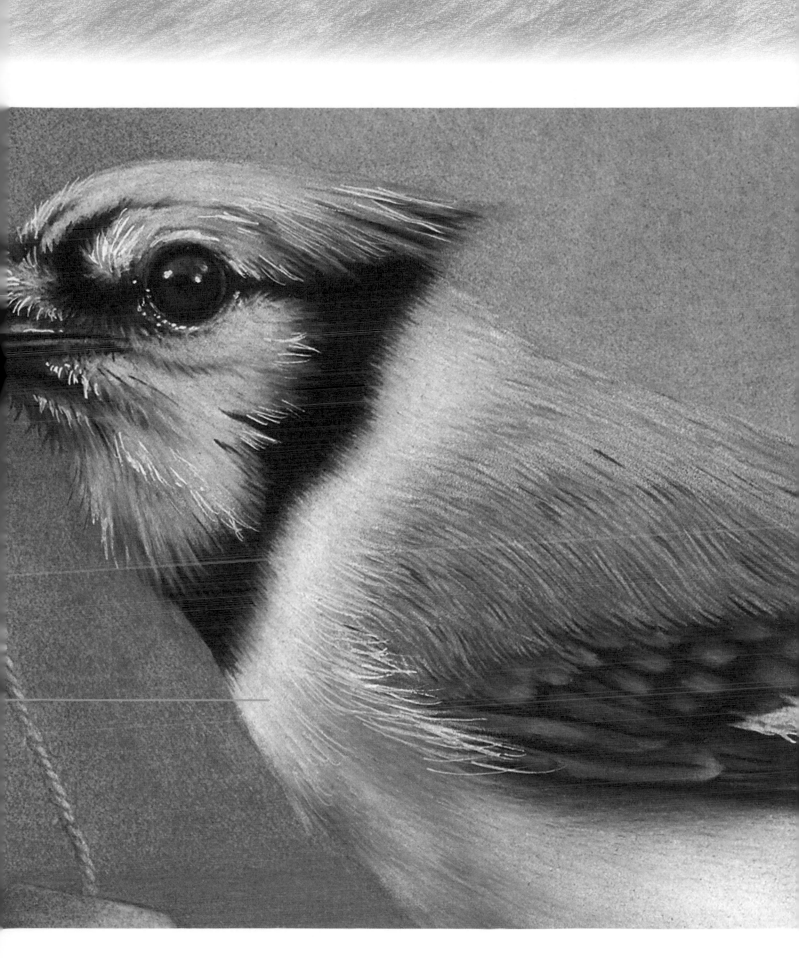

LAYERING TIPS, TECHNIQUES & TERMS

The first color you put down will be the truest to itself. In other words, what you see on the pencil is what you will get on paper. All subsequent layers will be altered by the previous layers.

It's difficult to get a light color or white to show up when layered over other colors. Plan ahead, and leave that area open to allow it to remain the white of the paper.

Always use a light hand and a sharp pencil to apply layers. This will maximize the total number of layers you can add.

BURNISHING

Layering a white or light color over darker ones is called "burnishing." When you increase your pressure, this process will blend the colors and compress them into the paper tooth, making them appear smoother and more solid.

SCUMBLING & STIPPLING

Scumbling, or scribbling in a random manner, allows for optical mixing on the paper, as does stippling, or creating small dots in an area. Practice both methods so that you have them at your disposal.

YOU CAN LAYER YOUR PENCILS IN MANY WAYS. YOU MAY WANT TO LAY DOWN YOUR COLORS SMOOTHLY, OR YOU CAN ADD A BIT MORE TEXTURE.

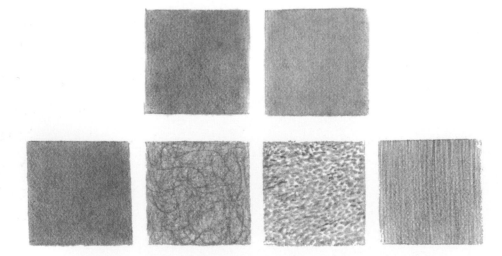

Practice all of the ways in which you can apply your colored pencils, and note the different effects you can create.

LAYERING COLORS

To layer colors, begin by adding a color that matches your subject's local color. Then add slightly darker layers where they're needed and lighter colors in the areas that need them. Keep going back and forth until you're satisfied with the colors and values in your drawing. You can also add light layers of unique colors to create visual interest and break up large areas of homogenous color.

If you use a steady and even amount of pressure as you work, it doesn't matter which colors you lay down first. But if you want one color to stand out, apply it on top of the others, or apply two layers of the same color.

Remember to experiment and practice. Create swatches of color mixtures, and use them as a reference. Not only will you gain a better understanding of how pencils interact and the colors you can create, but you can also begin to train your hand to smoothly lay one color over another.

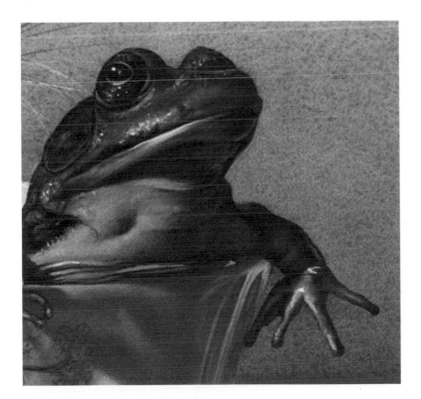

SIMILAR TO WHEN YOU PAINT, LAYERING TWO COMPLEMENTARY COLORS TENDS TO NEUTRALIZE EACH OF THEM. IN GENERAL, THE SAME RULES APPLY TO BOTH MIXING PAINTS AND LAYERING COLORED PENCILS.

Drawing with the Grain

Following the contour of a subject as you draw is good practice, but it is only noticeable when you apply the final layer. If you apply the beginning layers smoothly, you can choose your stroke and direction and switch to a more directional contoured stroke for the final layer.

Drawing with the grain or contour of a subject can help you develop the proper value shifts across the form, and it will aid you in visualizing the shape three-dimensionally. When you consciously apply your pencil strokes with the grain of your subject, you will gain a greater appreciation for its shape and the way that the light moves across its surface.

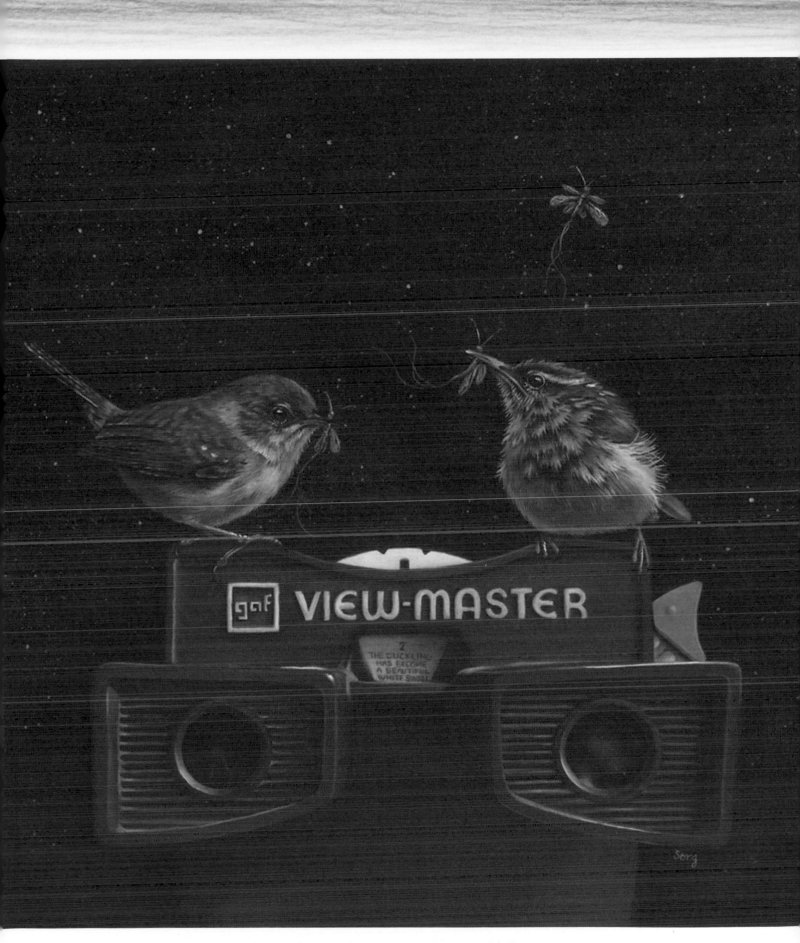

Notice the shape of your subject as you draw, and follow its contour.

Blending

Blending colored pencil allows you to build up form and transition values. With practice, you will learn to blend all the colors available to you simply by adjusting how much pressure you apply to a pencil.

Blending can be used to enhance a drawing, so it's helpful to know all the ways in which you can blend colored pencils. In general, blending techniques fall into two categories: dry and wet.

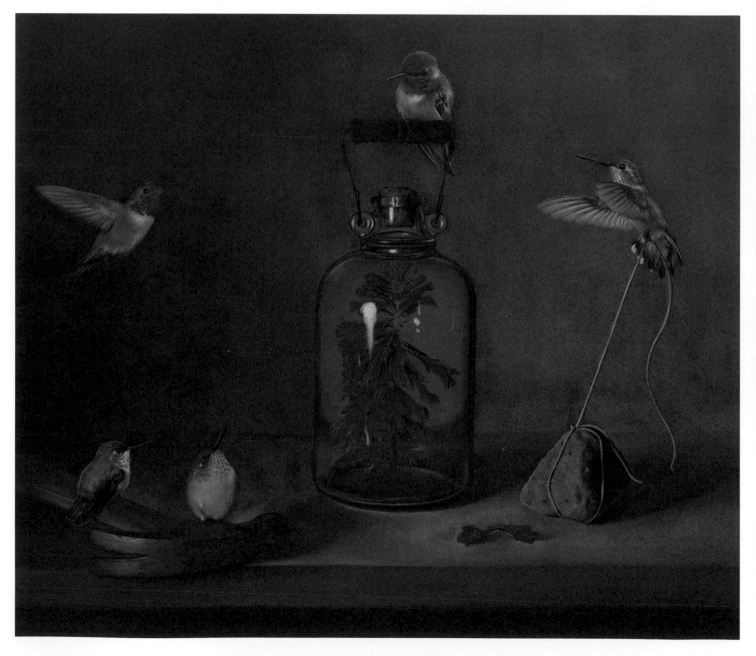

Well-blended colors make your subject look realistic.

DRY BLENDING

COLORLESS BLENDER OR BURNISHER: This pencil contains just wax without added pigment, and it works by way of friction. It creates a glossy effect that's useful when drawing a shiny object like an apple, an eye, or polished metal.

Apply smooth layers of colored pencil for the best effect, and make sure to use at least two layers of wax. Once the waxy base layers are in place, you can go over the area with a burnisher, working in small circles and applying medium to hard pressure. Working in small areas will keep you from smearing darker colors into lighter areas. Notice the sheen developing over the now-burnished area.

Now you can add any details, applying more pressure to the pencil if necessary to keep them visible.

DRYBRUSHING: This can be used to blend colors and hide any paper tooth that shows through without making the surface shiny. It's the perfect technique for creating even, smooth blends for subjects like the sky and skin tones.

You'll need a cheap, relatively stiff hog-bristle brush. Just as with burnishers, make sure there are one to two (or more) smooth layers of wax without any detail on the paper. Then scrub the dry brush over the pencil, and blend the waxy pigment. The heat generated by the friction will liquefy the wax and move it around.

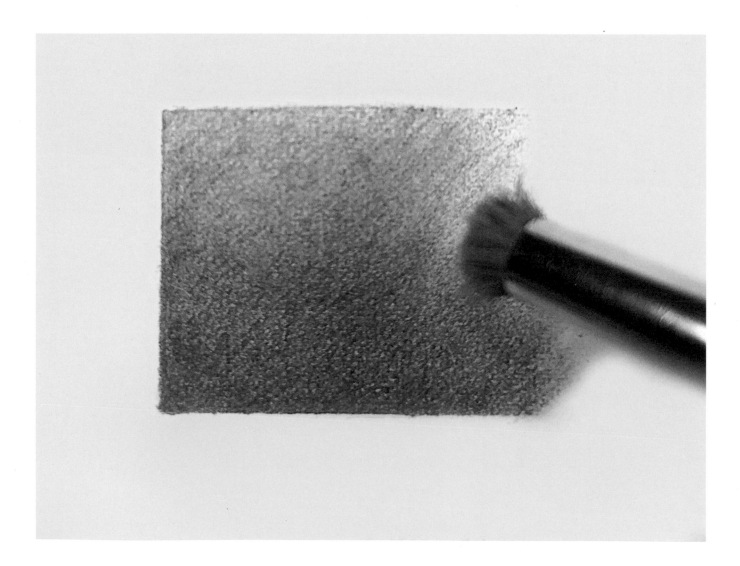

ADDING HEAT: You can also use a hair dryer or heat gun to heat and soften layers of wax. Softening wax makes it easier to move around on your paper. Once the area you want to blend is evenly heated, buff it with a piece of cotton cloth, cotton swab, or blending stump to smooth the layers together.

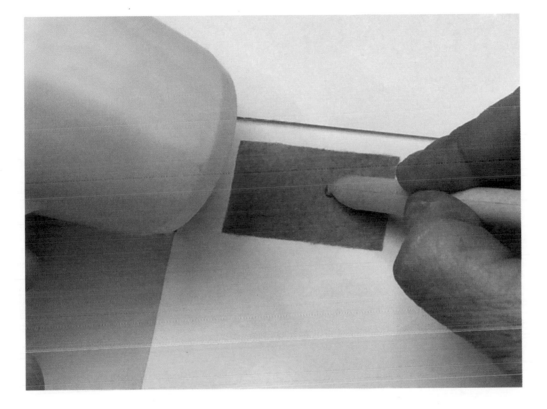

WET BLENDING

Wet blending temporarily turns dry colored pencil into paint. Once it dries, you can layer over it and blend as needed.

Apply several layers of color prior to blending without worrying about keeping the colored pencil smooth, as solvents will dissolve and redistribute the pigment. The more color and wax you have down, the more of the effect you will see.

You will need a small amount of solvent and a cotton swab to melt, soften, and blend your layers of colored pencil. Once dry, continue drawing as before.

Rubbing alcohol can be used exactly the same way and offers a great alternative for people with sensitivities or who prefer not to work with chemicals.

BLENDING PENS: These can be used to move colored pencil into and around paper. Simply apply your layers, and then run the pen over them until the colors look well-blended. These pens will pick up color, so plan ahead, and have several on hand to keep similar colors together.

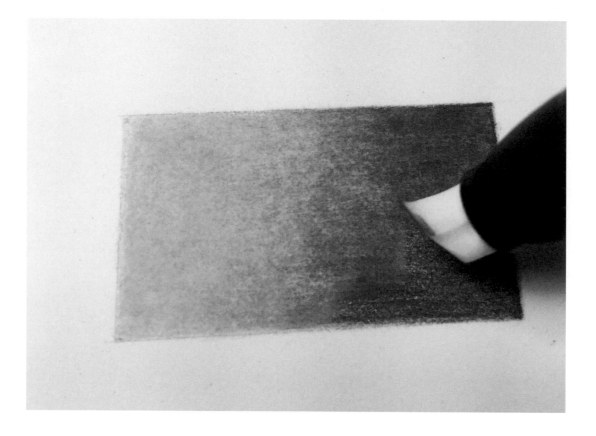

**BLENDING PENS ARE
A MORE PORTABLE
BUT EXPENSIVE
TOOL FOR BLENDING
COLORED PENCIL.**

The Fine Art of the Taper, or Manual Blending

Tapering is vital for blending two or more adjacent colors. It's a simple concept that doesn't require any tools or tricks, but it can take some time to develop the dexterity needed to execute it successfully.

Gradually reducing the amount of pressure you apply to your pencil is key. As you layer the pencil and move into an area of your paper that requires a new color, add less and less pressure until you leave almost no marks on the paper. This will create a smooth shift in saturation.

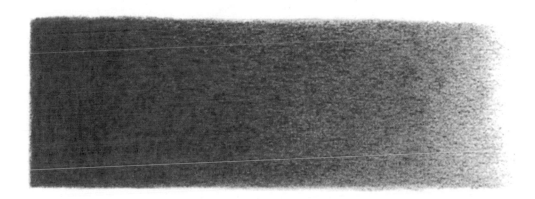

Then add another color and work in the same way, lightly tapering into the edge of the previous color and increasing your pressure as you move away.

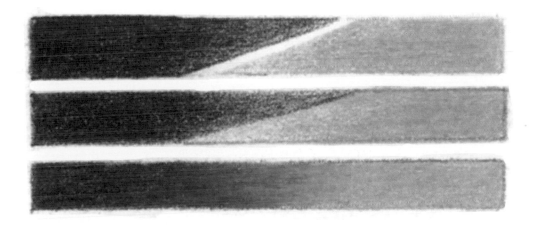

In this piece, I used a very sharp pencil to keep the layers in the sky as smooth and well-blended as possible. Leaving some areas lighter indicates clouds.

IMPRESSING A LINE: This technique can be used to preserve specific areas in a drawing using the white of the paper or to keep an area a certain color before layering over it.

Pushing a hard object like a stylus into the paper creates a controlled dent that the pigment can't reach. Use this technique to draw fine hairs or whiskers and small highlights or to preserve your signature.

Just draw over the area you want to protect with the stylus, and continue drawing. The lines will be hard to see at first, but as you apply color, they will quickly reveal themselves.

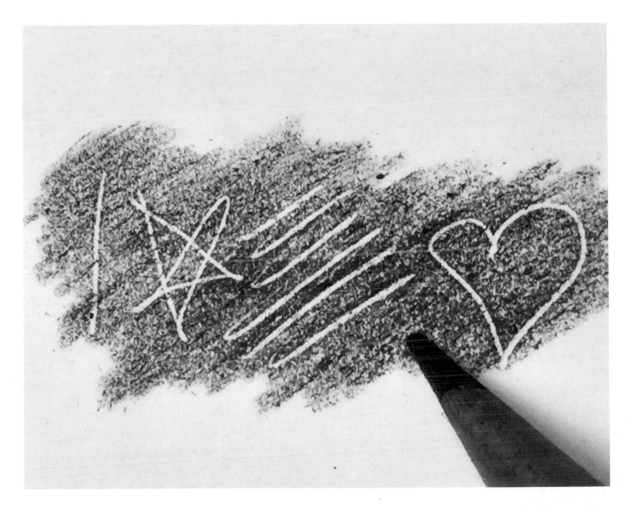

tip

USE A BALLPOINT PEN IF YOU DON'T HAVE A STYLUS. JUST MAKE SURE TO PROTECT YOUR DRAWING WITH TRACING PAPER, AND DRAW OVER THAT.

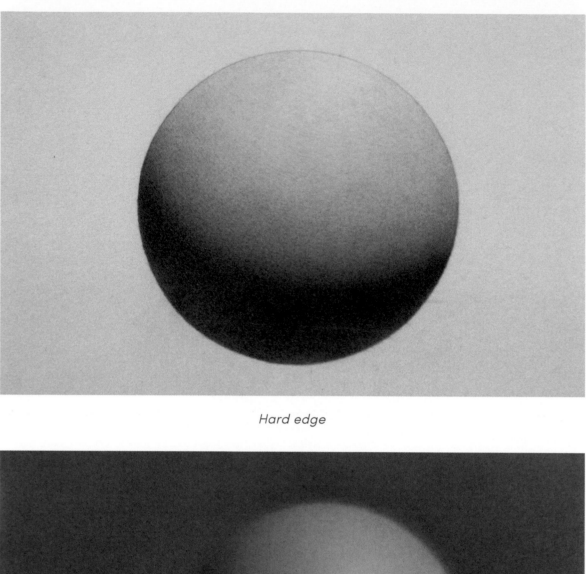

Hard edge

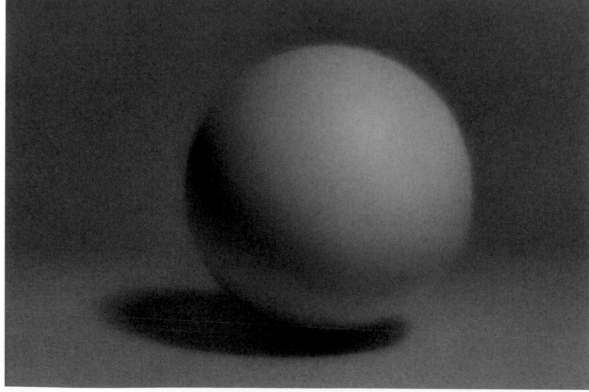

Soft edge

Soft vs. Hard Edges

Using the appropriate edge in a drawing is crucial to the final artwork's strength, so it's important to know when to use a hard edge and when to use a soft one.

Hard edges tend to draw in the viewer's eye, so it's best to place them near your focal point. When something appears crisp and clean, the eyes perceive it as close, so using hard edges on a subject can create the illusion of nearness.

In contrast, soft, blurry edges create the impression of distance between the viewer and the subject. Using this type of edge pushes a subject back in space.

Soft edges can also help illustrate that an object is turning. This is best visualized in drawings of spheres. When soft edges are used to render a sphere, it appears round and three-dimensional. When drawn with hard edges, the same sphere will flatten out and appear to have less volume.

OFTEN, USING A LITTLE OF EACH TECHNIQUE OFFERS THE BEST APPROACH. TOO MANY HARD EDGES AND YOUR IMAGE WILL APPEAR FLAT; TOO MANY SOFT EDGES AND YOUR VIEWER'S EYE WILL NOT KNOW WHERE TO REST.

Building a Base

I like to think of creating a base for my drawing as the problem-solving portion of the job. This is when I choose my local colors (page 18) and gain an understanding of the anatomy of my subjects by paying attention to light and shadow. I also prepare myself for the detail work that will follow.

A strong base holds the entire drawing together, so it's worth taking the time to develop one. It should include:

- The first several layers of local color
- All values, from lightest light to darkest dark
- Smooth transitions of value and color
- No details

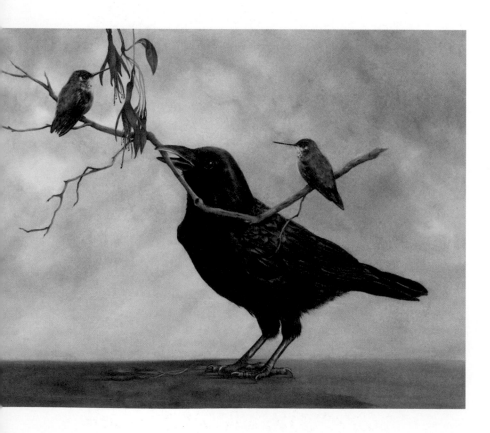

BASE IMPORTANCE

I find it easier to make decisions about color and value if I don't have a large area of exposed white paper in front of me, so I recommend applying a base layer over your entire drawing before moving on to detail work. However, you can also work each section to completion if that's your preferred approach.

It may be helpful to burnish your base color (see page 48 for more on burnishing) with a dry brush or solvent to ensure that the paper tooth is entirely covered and that all of your colors are smoothly blended.

A base can help create an appealing result and demonstrate how little detail you actually need in a good drawing. From there, it is up to you how many or how few actual details you want to add.

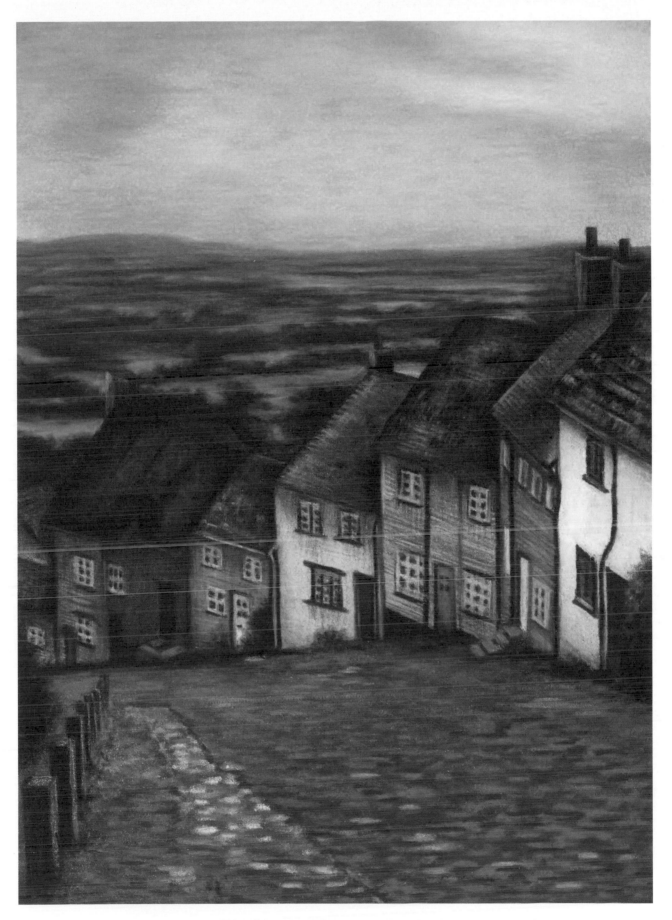

Here I started with a base of different shades of green. Then I added gray to push back the skyline and create a sense of atmosphere.

Scratching Out

Similar to the impressed-line technique (see page 59), scratching out means making a mark without adding pigment. Because the goal is to expose the white of the paper, scratched lines are most visible when made over darker colors.

The process itself is simple: Using a craft knife or any other sharp tool, scrape away at the area you wish to expose, taking care not to cut through all the layers of the paper and create a hole.

USE THIS TECHNIQUE TO DRAW INDIVIDUAL LINES IN WHISKERS AND FUR AND TO BUILD UP LARGER AREAS OF TEXTURE IN A LANDSCAPE.

Frottage

Frottage is a technique used to make an impression of the surface texture of a material, such as fabric or wood. To achieve frottage, place a sheet of paper over a textured surface, and rub it with a colored pencil to create a pattern. After creating your initial pattern, enhance and embellish it with additional layers and tones of colored pencil.

FROTTAGE CAN BRING INTERESTING AND REALISTIC-LOOKING TEXTURES INTO A DRAWING, AND IT CAN CREATE THE IMPRESSION OF DEPTH.

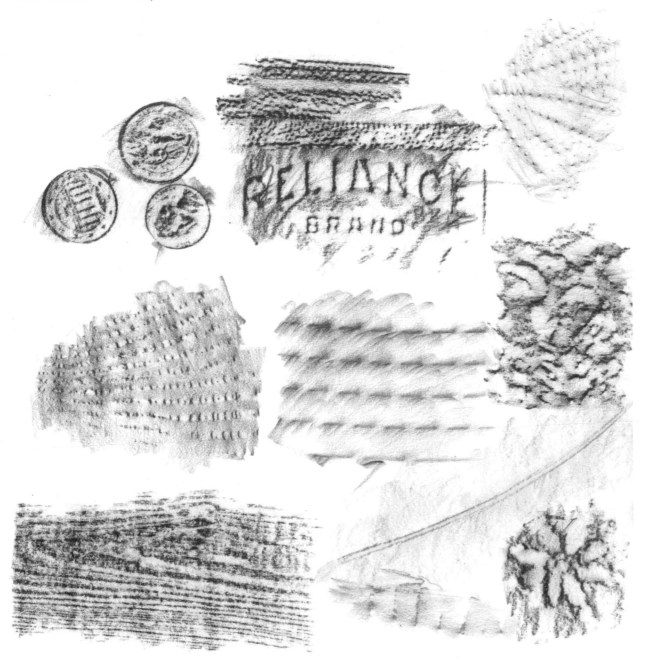

Highlighting White in a Drawing

When drawing with colored pencils, you must preserve and maintain the white of the paper whenever you need white in your artwork. This can be tricky, as it is difficult to fully protect an area while you work on the rest of a drawing.

Wax-based white pencils are not opaque enough to create a bright white. Also, working around an area to preserve the white of the paper can remove the spontaneity and natural feel of your marks. Here are some ways to add white back to a colored-pencil drawing even after you're almost finished with the piece:

- **White water-soluble pencils** can be softened and applied directly or with a liner brush.

- **Opaque white gel pens and markers** work well for adding small details and highlights.

- **Gouache** can effectively add lines and larger areas of white to a drawing when applied carefully using a liner brush.

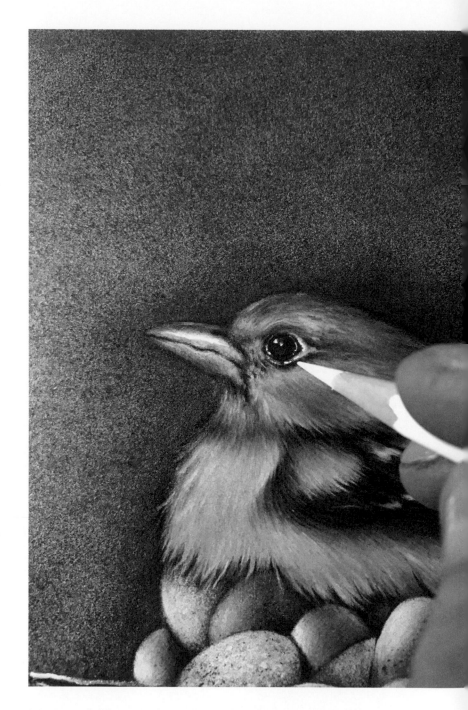

Water-soluble pencils create a detailed, precise effect, so they work well for creating white highlights in a drawing.

tips

USE A LINER BRUSH TO ADD GOUACHE TO A DRAWING AND CREATE LARGER WHITE AREAS THAN ARE POSSIBLE WITH JUST COLORED PENCILS.

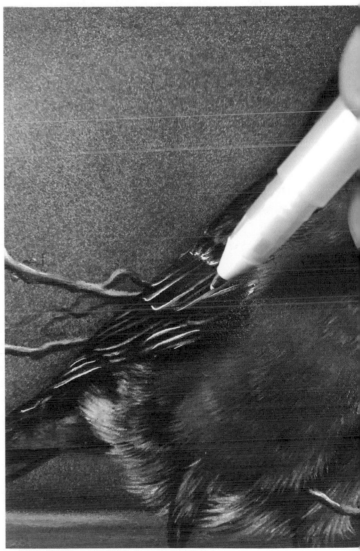

tips

YOU CAN ALSO USE A WHITE PEN OR A MARKER TO ADD HIGHLIGHTS.

Mixed Media Mentions

Using a variety of mediums within a work of art can add richness to a piece. It allows you to exploit each medium's best qualities while also making the creative process more varied and interesting.

Colored pencil works well for creating softness and detailed lines, making it the ideal medium for finishing a loose underpainting, collaging, or adding touches of color to a black-and-white piece. Using other mediums in conjunction with colored pencil will also allow you to work with larger formats.

YOU CAN APPLY BIGGER AREAS QUICKLY USING ANOTHER MEDIUM, AND THEN ADD FINAL DETAILS OVER THE FOCAL POINTS TO COMPLETE YOUR PIECE.

When mixing pen with colored pencil, use ink before adding colored pencil. Ink doesn't apply well over colored pencil, and the wax in your colored pencils can clog your pens.

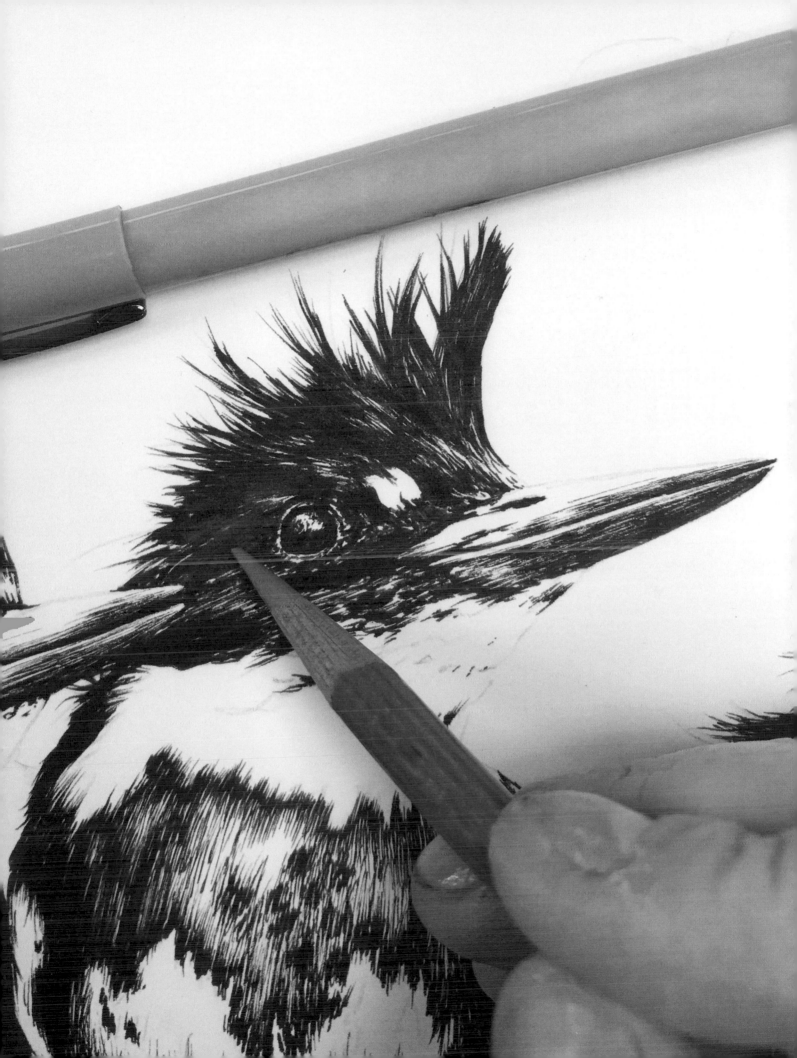

MIXING IT UP

Try combining the
following mediums
with colored pencil:

- Pen and ink
- Marker
- Graphite pencil
- Watercolor
- Acrylic
- Pastel
- Collage
- Encaustics
- Charcoal

tip

YOU CAN CREATE A GOOD BASE AND SIMULATE THE LOOK OF WOOD BY COVERING A WHITE SHEET OF PAPER WITH BLACK INK AND BROWN WATERCOLOR.

tip

APPLY COLORED PENCIL OVER AN INK-AND-WATERCOLOR BASE. COLORED PENCIL SOFTENS THE TONES AND ADDS DETAILS.

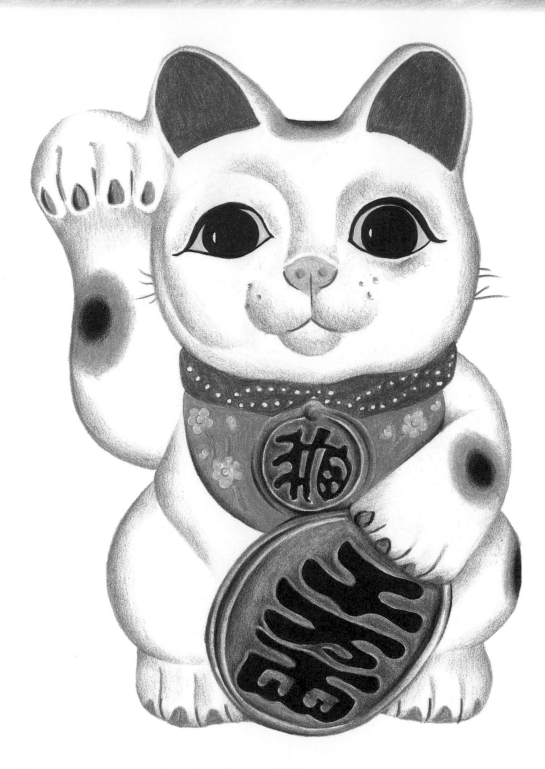

ONE VERY IMPORTANT TIP: COLORED PENCIL IS A SLOW MEDIUM, SO TAKE YOUR TIME WITH YOUR DRAWINGS, AND DON'T GET IMPATIENT. PAY CLOSE ATTENTION TO YOUR REFERENCE PHOTO, IF YOU USE ONE, AND WORK SLOWLY TO CREATE THE ARTWORK YOU WANT.

Problem-Solving Suggestions

In life, mistakes happen. In art, you can view mistakes as an opportunity to adapt. Without mistakes, you won't learn as much, so embrace your mistakes, and try looking at them in a more positive light.

Here are three common issues you may encounter while drawing with colored pencils as well as ways to work with them.

1. YOU'VE CHANGED YOUR MIND

Should you wish to make a major correction to your drawing, such as adding or removing an element, you will need to remove all of the previous layers of pencil down to the bare paper. Take your time to avoid damaging the paper by applying too much pressure to your eraser or by using an abrasive type of eraser.

Once you've exposed the paper, begin again, making the changes that you wish to make. Depending on how compressed the paper is, you may have to limit your number of layers and/or colors. Make each mark count!

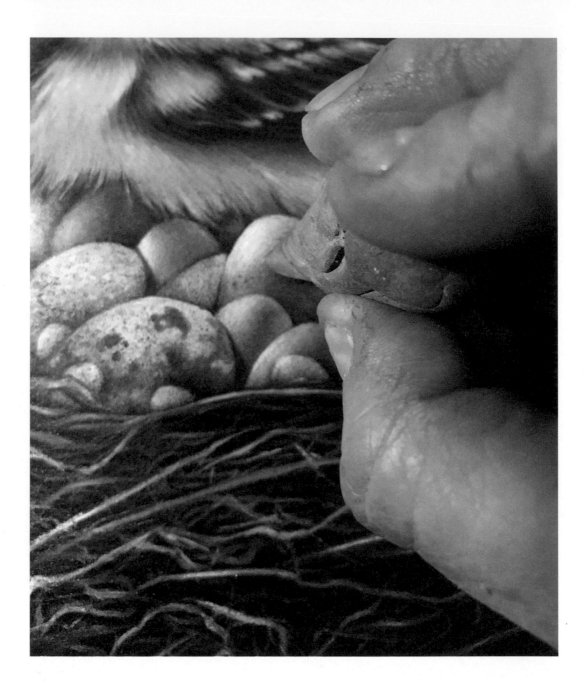

2. LAYERS THAT WON'T STICK

This usually indicates either that you've applied too much pressure to your previous layers or that your paper has reached its saturation point.

The best solution is to use a kneaded eraser to carefully remove some of the wax. Shape the eraser to your desired size, and do not remove all of your pencil layers—just enough so that you can add another layer or two to fix your mistake.

3. DENTS IN THE PAPER

Your drawing paper can get dented if you drop or press something on it. These dents are essentially impressed lines that you may not notice until you begin drawing.

To plump up your paper, use a cotton swab to apply water to the affected area, and allow the water to soak in. Make sure you remove any wax layers prior to adding water to prevent resistance.

Once the paper is completely dry, draw over it with a very sharp colored pencil to make marks in any remaining pockets in the paper.

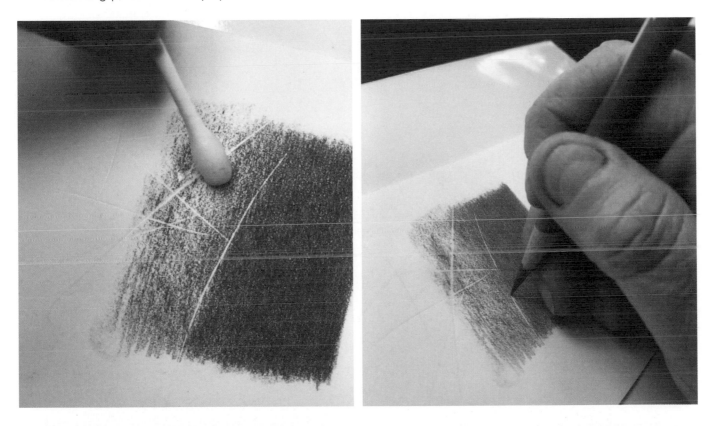

WORST-CASE SCENARIO

For the really tricky problems that can't be solved by erasing or adding layers, consider drawing another element over or near the spot in question. Try using color or objects to distract viewers' eyes from your mistake.

If the area ends up looking overworked or if you create a hole in your paper, you may have to get creative and crop that segment of the drawing from your final image. A piece of a mat can cover any mistakes in a drawing and shore up flaws.

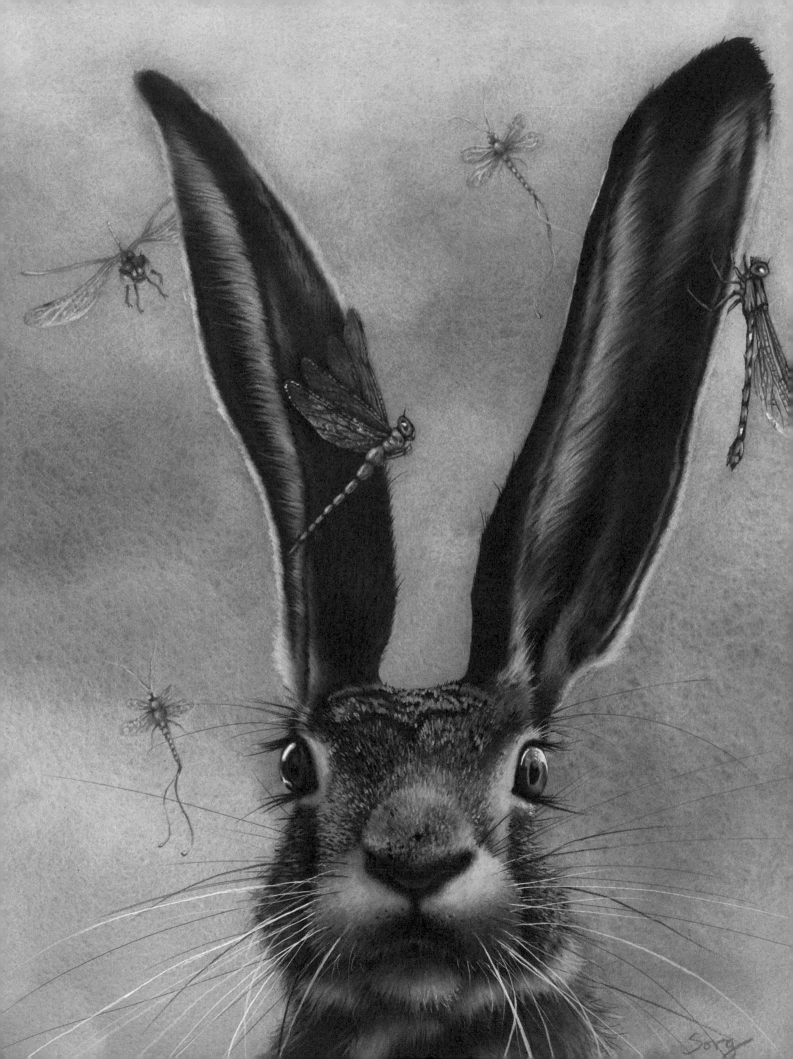

Mastering

WHAT YOU'VE LEARNED

Soft Layers & Smooth Transitions

This drawing project showcases the softness that can be achieved with colored pencils when you concentrate on soft layers, taper your edges for smooth transitions, and use soft and hard edges to depict a subject.

MATERIALS USED

Reference photo; sheet of paper (such as Stonehenge); stylus; kneaded erasers; colored pencils (I used Faber-Castell's Polychromos as well as Prismacolor) in dark sepia, sienna brown, sand, goldenrod, henna, light peach, black, white, putty beige, imperial violet, Copenhagen blue, terra-cotta, and aquamarine; colored marking pencil in white; stiff brush; and fine liner brush

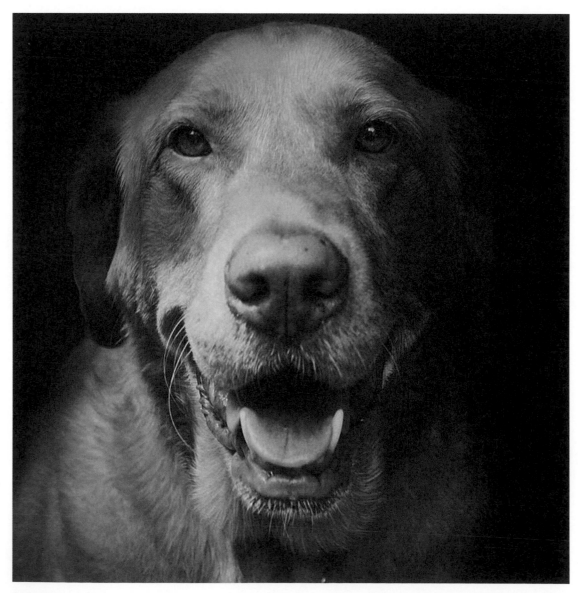

Reference photo

KEEP YOUR LINES JUST DARK ENOUGH SO THAT THEY'RE VISIBLE, AND TRY NOT TO PUSH SO HARD THAT YOU DENT THE PAPER.

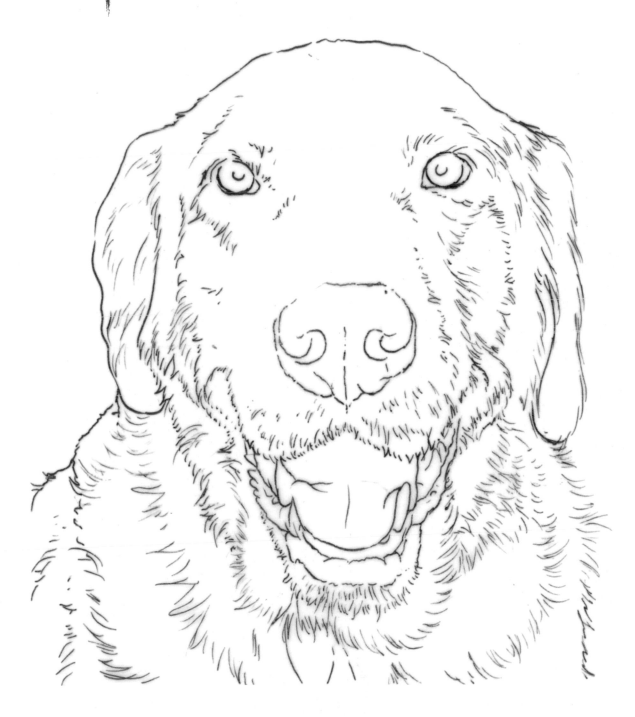

Transfer your drawing using the light-box method (page 26) or a sheet of transfer paper.

Using a stylus, draw the whiskers and other prominent white hairs on the dog's face. You can also use the stylus to sign your name.

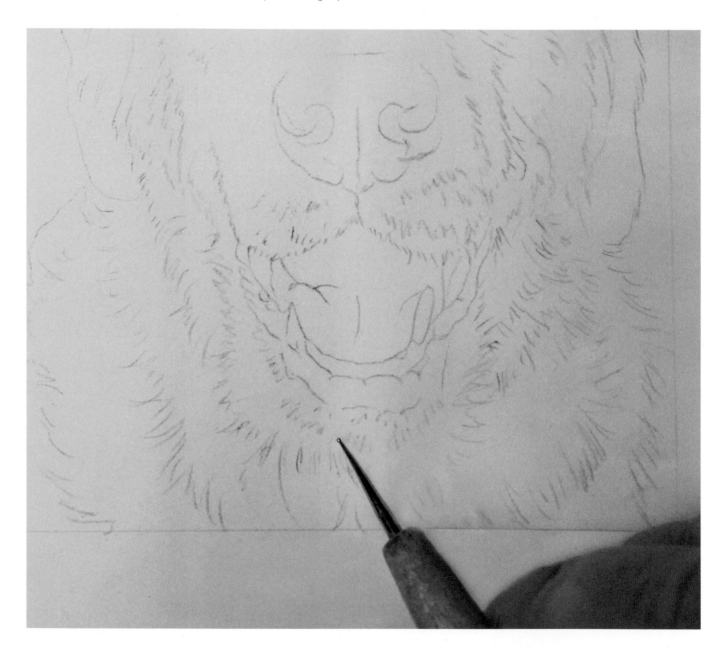

A STYLUS INDENTS STROKES IN THE PAPER, SO WHEN YOU SHADE OVER THEM WITH PENCILS, THE WHITE LINES STAY INTACT.

TO DARKEN A SPOT, GO OVER IT MULTIPLE TIMES RATHER THAN PUSHING HARDER ON YOUR PENCIL. LEAVE ANY AREAS THAT YOU WANT TO REMAIN WHITE CLEAR OF COLOR.

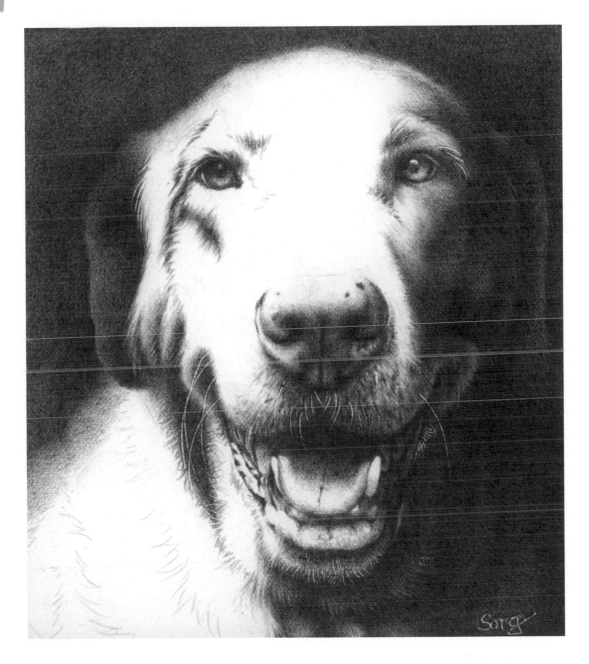

Using dark sepia, begin by laying in shadows and darker areas. Work with a sharp point so that you cover the hills and valleys in the paper without placing too much pressure on your pencil.

Use any stroke that feels comfortable; this is the bottom layer, so your goal is simply to create a smooth, even coat. I like to scumble or use circular strokes until I add details.

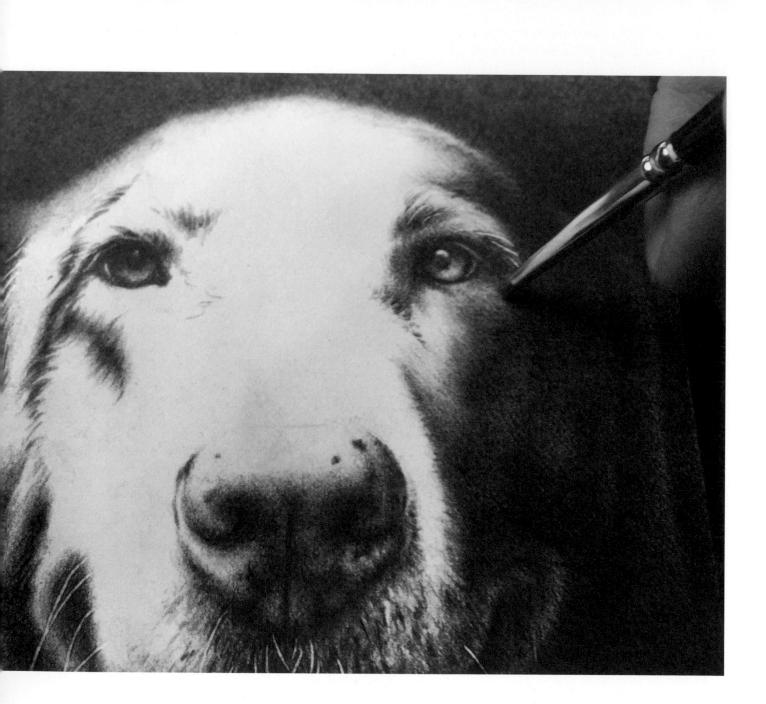

Use a stiff, dry brush to smooth the bottom layer and hide any paper that shows through. Scrub in small circles, taking care to keep clean the areas that should stay white.

Now start adding local color. Apply sienna brown using the same technique you used with the sepia, but add it just in the areas that need a lovely auburn color, such as the eyes. Layer over and into the sepia, taper off where it appears lighter, and create smooth transitions.

At this point, apply color just to define the dog's form without worrying about specific details.

tip

PLACE A SHEET OF PAPER UNDER YOUR HAND TO AVOID DRAGGING COLOR AROUND, AND USE A KNEADED ERASER TO BLOT ANY AREAS THAT LOOK DIRTY.

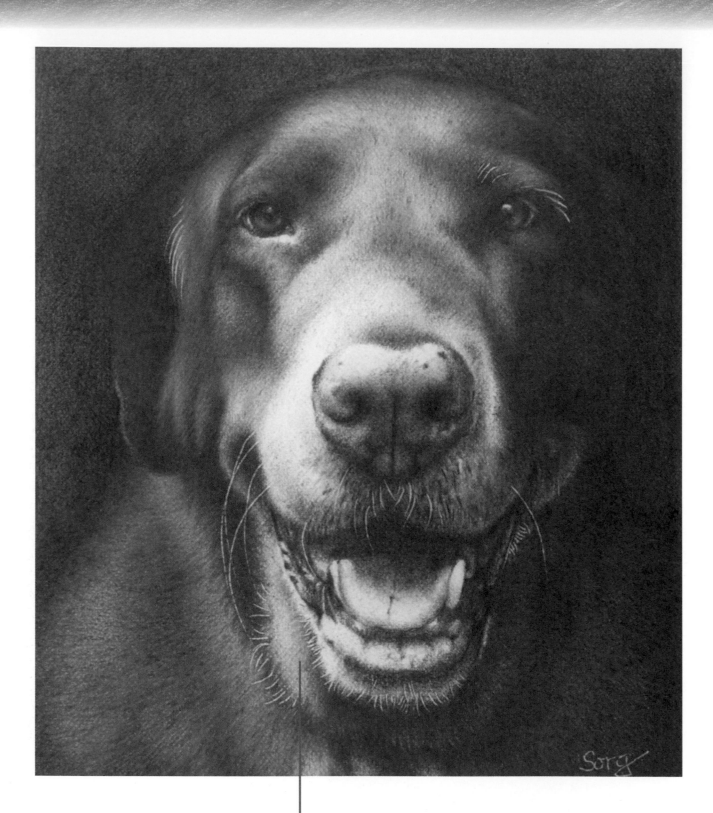

Work with brighter colors now. Add sand and goldenrod where you notice a golden sheen in the dog's fur. Carry these colors into the previous layers as needed, and keep them smooth. The dog's anatomy should come together now, as much of the value range is already in place.

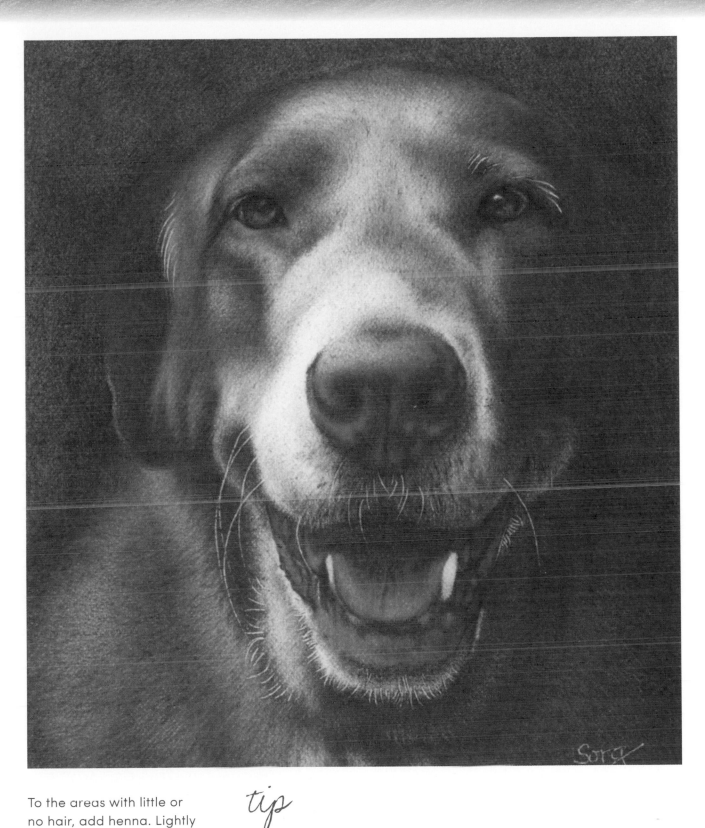

To the areas with little or no hair, add henna. Lightly layer this color over the nose, mouth, tongue, and around the eyes.

Blend in light peach to indicate highlights.

tip

KEEP CHECKING YOUR REFERENCE PHOTO TO SEE HOW THE LIGHT MOVES ACROSS THE DOG'S FACE.

85

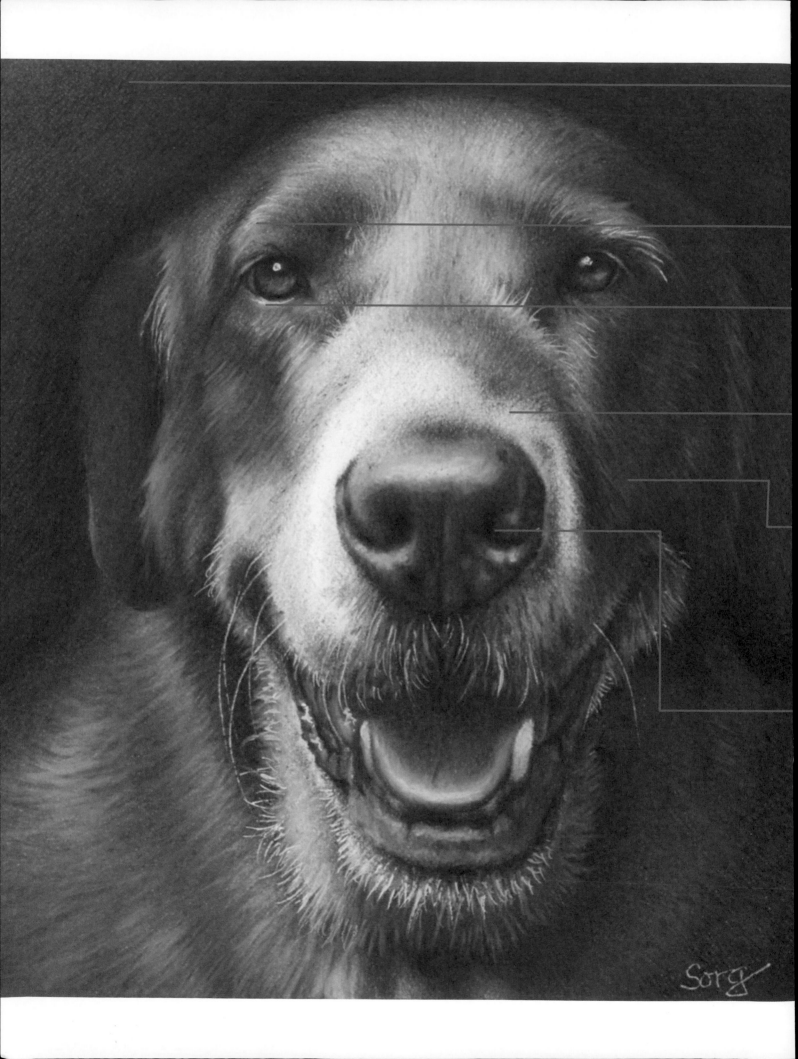

Check your reference photo for any unusual colors that stand out. If you add a color to the background, you must add it the foreground as well, so add blue and purple to the background and to the dog's coat. The dog's fur features areas of more intense ochre; add terra-cotta there. Then add touches of aquamarine to contrast with the brown and orange tones.

Now you can create details, sharpen values, and add pops of color. The left side of the dog's face is closest to the light source, so use white to draw details there.

Use the white marking pencil to brighten white areas and highlights. First use the pencil dry, and then dampen it, and apply with a fine liner brush.

When drawing details, remember that a little goes a long way. Your viewers' eyes will fill in the missing details, so don't draw every single hair. Add finer lines in and around the focal points, leaving receding areas with softer edges and fewer details.

Use putty beige to follow the same steps on the shadowed side of the face. Using a slightly darker, cooler-temperature color adds dimension and roundness to the dog's face.

Use a black pencil to darken the areas that should appear to recede, such as the nostrils. Keep your edges soft. Also with a sharp black pencil, add darker hairs around the face.

tip

IF A LINE APPEARS TOO BRIGHT, RUB IT WITH YOUR FINGER TO TONE IT DOWN, OR DRAW OVER IT WITH A DARKER PENCIL.

Value Changes & Subtle Shifts

When drawing a portrait, pay close attention to the value changes across the skin's surface. People's faces rarely have hard lines but rather soft edges. Gradual transitions from one color to the next and knowing how to evenly taper a layer and letting it fade are essential.

MATERIALS USED

Sheet of paper (such as Stonehenge); colored pencils in dark sepia, light umber, seashell pink, putty beige, cool gray, henna, kelp green, light peach, blush pink, terra-cotta, dark brown, parma violet, Copenhagen blue, mineral orange, sand, white, black, goldenrod, and magenta; stylus; kneaded eraser; drybrush; and utility knife

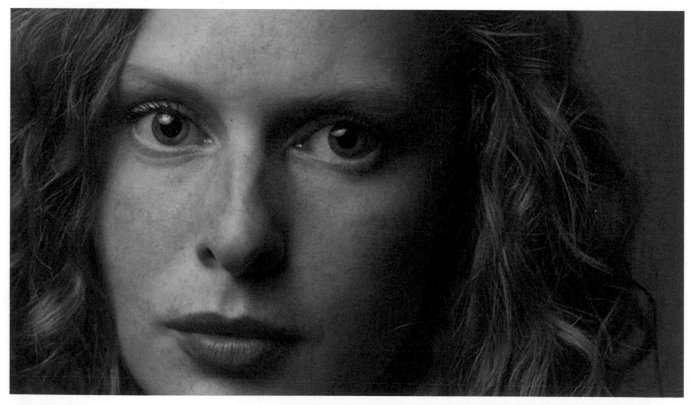

Reference photo

Make a line drawing, and then transfer it onto a clean sheet of paper, taking care to keep your lines light but still visible.

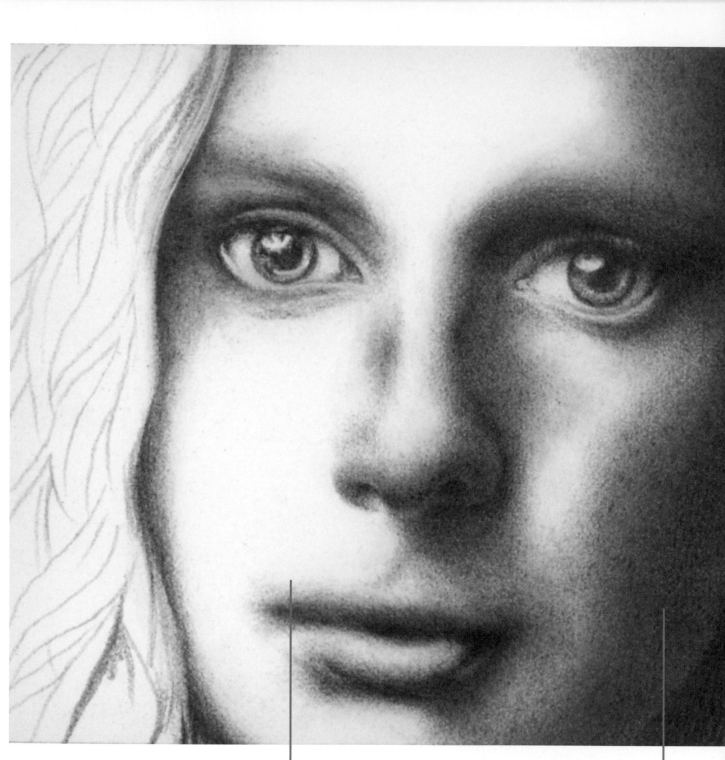

Use light umber for the shadows that fall on the lighter side of the face.

Add some shadows. The reference photo features strong lighting, making one side of the face much darker than the other.

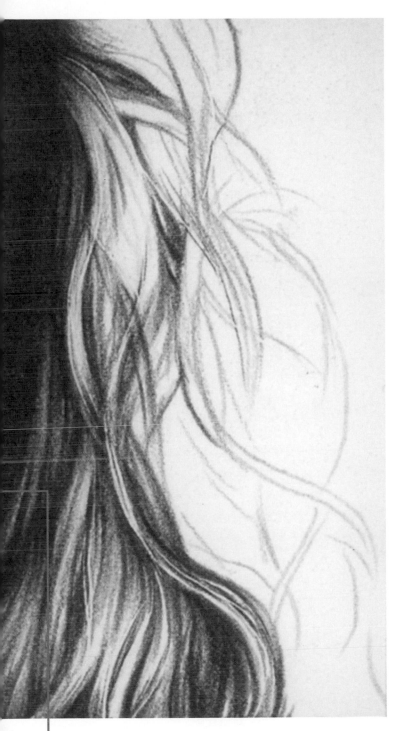

Use dark sepia for the darks on the right side.

WORK WITH A LIGHT HAND; YOU'LL NEED MANY MORE LAYERS ON TOP.

Use a stylus to draw impressed lines and indicate fine hairs, and indicate shadows in the hair using dark sepia and light umber.

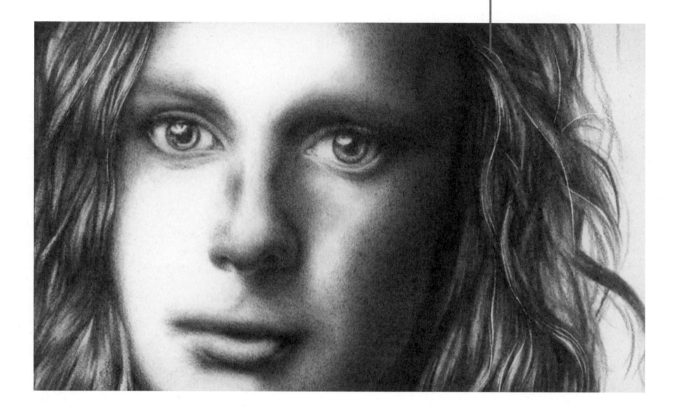

tip

USE A VERY SHARP PENCIL TO CREATE EVEN LAYERS AND TO HELP WITH THE TAPERING PROCESS.

Add a single layer of seashell pink over the face and lips.

Leave white any brightly reflective areas, like the nose and forehead.

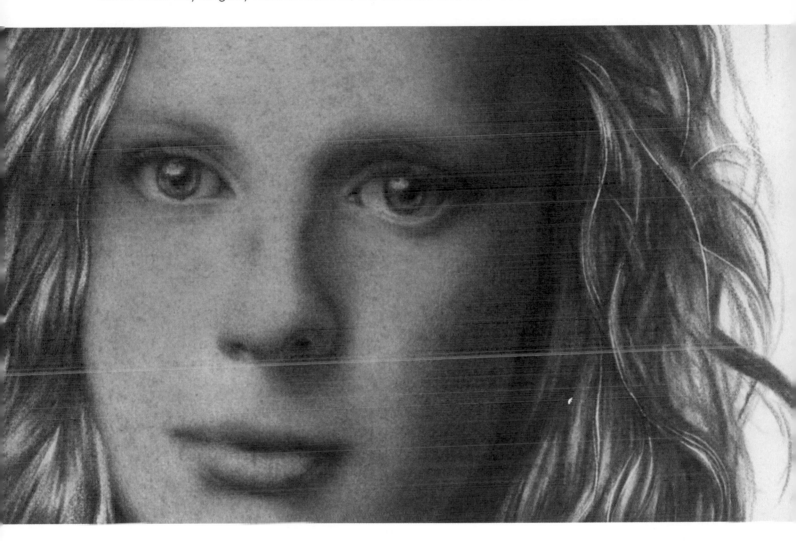

tip

KEEP YOUR DRAWING PROCESS SIMPLE BY LOOKING FOR LARGE SHAPES AND DRAWING WITHOUT INCLUDING MANY DETAILS, SUCH AS INDIVIDUAL STRANDS OF HAIR.

Add kelp green to the iris, and
tone it down with cool gray.

Continue adding skin tone using
light peach and mineral orange.

Leave the paper white to add highlights,
and darken the whites just below the
upper lid with cool gray and putty beige.

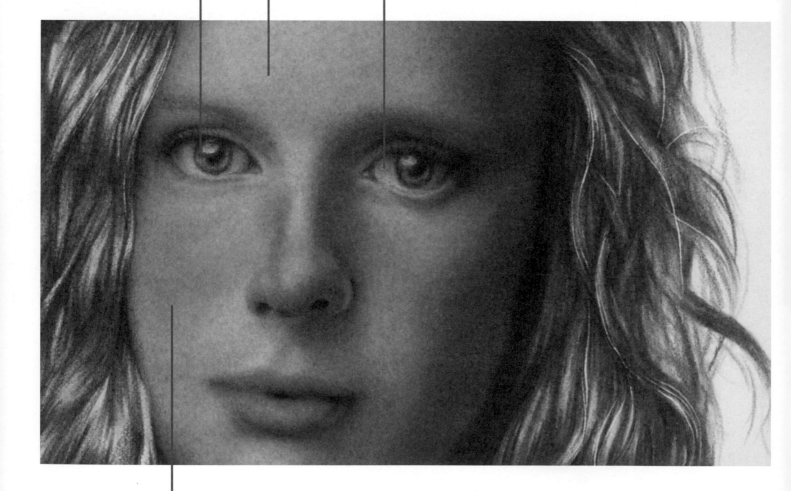

Use blush pink to add color to
more vascular areas, such as the
nose, forehead, and cheeks.

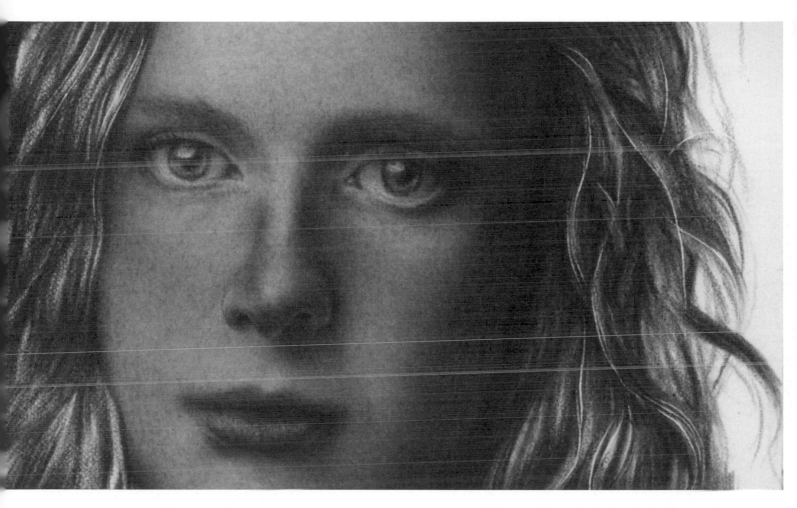

Bring red tones into the hair, lips, and dark shadows of the face using terra-cotta and dark brown.

Deepen the rosy areas in the lips and face with henna.

tip

USE THE DRYBRUSH TO SOFTLY BLEND EVERYTHING.

LIGHT LAYERS WILL
LIVEN UP A PORTRAIT.

A layer of kelp green and Copenhagen blue in the background complements the skin and hair. Drybrush these colors to smooth and blend them into the hair.

Bring Copenhagen blue and parma violet into the shadows of the hair and face.

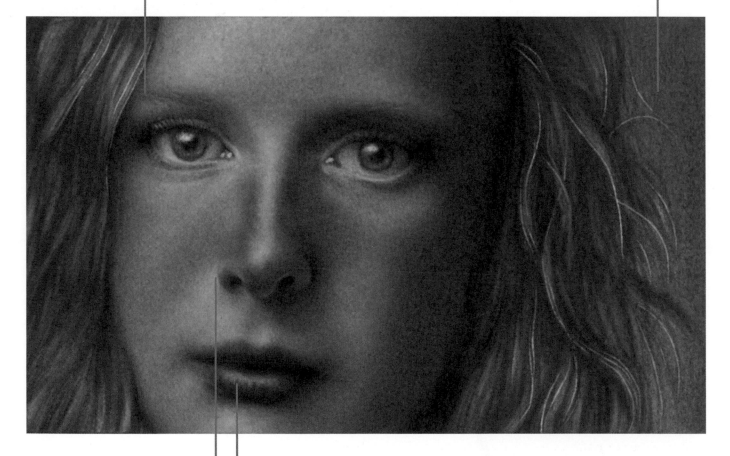

Layer magenta over the lips. Use light peach and white to bring out highlights in the lips and face.

Make sure to check the overall tones of the face, and add or subtract color (use a kneaded eraser) as necessary.

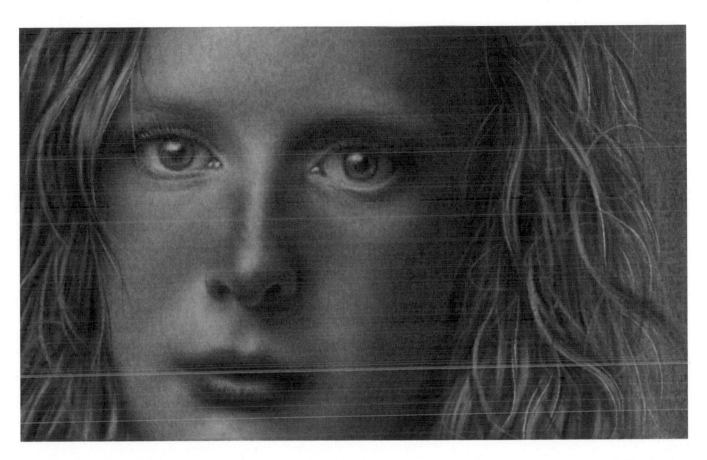

For a final touch, use goldenrod to add brightness near the eyes, nose, mouth, and hair. Use a utility knife to scratch out individual strands of hair. Let the strands cross over the face to add depth.

Darken any deep shadows using dark sepia and black.

Add individual hairs with any color, using an energetic scribble stroke to indicate wild curls. Simply suggest the curls, and the viewer's eyes will fill in the rest.

If the edges appear too hard, use the drybrush to soften them.

Colors & Contrast in a Still Life

A still life featuring a floral subject can look calm and subdued or strong and powerful, as well as everything in between.

In this reference photo, the vibrant colors and high contrast in value make for a bold image. This project gives you the opportunity to practice tapering, blending, and using hard and soft edges, and it shows the importance of working with the grain of your paper to build the structure of a subject.

MATERIALS USED

Sheet of paper; colored pencils in cool gray, crimson-aubergine, ruby red, yellow ochre, lime peel, marine green, kelly green, putty beige, white, canary yellow, lemon yellow, lilac, black, yellow-orange, light aqua, and orange; brushes for blending and outlining

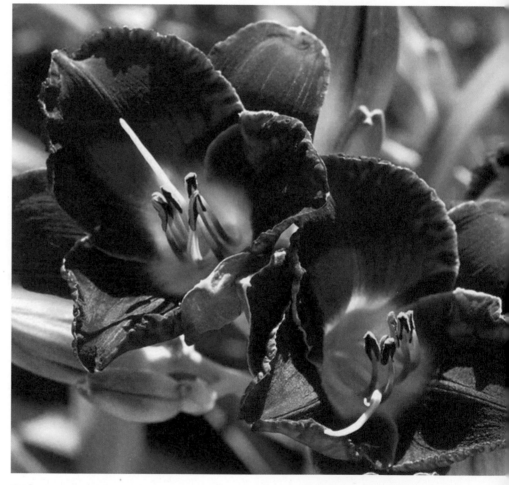

Reference photo

I USED THE COLORS LISTED HERE, BUT YOU CAN CHOOSE ANY VARIETY OF COLORED PENCILS WHEN DRAWING A FLORAL SUBJECT.

Transfer your line drawing onto a smooth sheet of paper using transfer paper or a light table. Attach it to a piece of hardboard, and tape it down so that only your drawing area remains visible.

Use cool gray to draw the darker areas of the image. Keep the edges soft, and vary your pressure. Blend with a stiff blender brush if any areas don't look smooth and even.

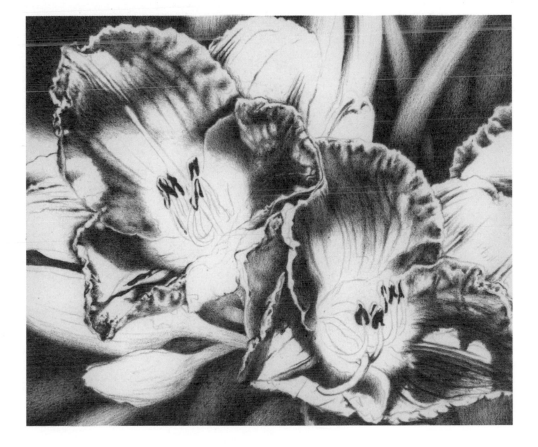

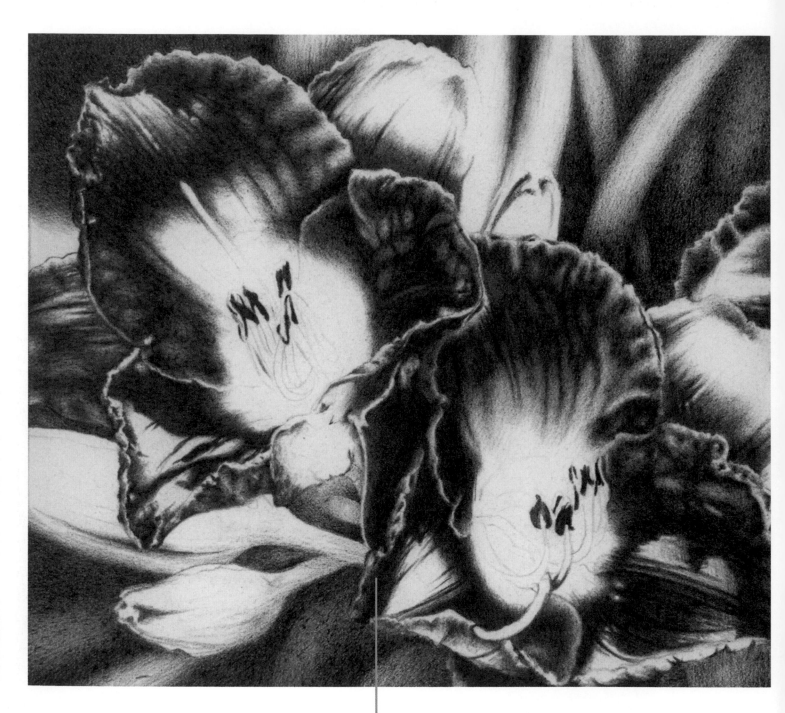

Apply crimson aubergine over the flowers, their buds, in the darker areas of the image, and into other parts of the petals to establish the local color. Blend with a brush.

Continue laying in the flower petals using ruby red.

Leave white the very lightest highlights for maximum impact.

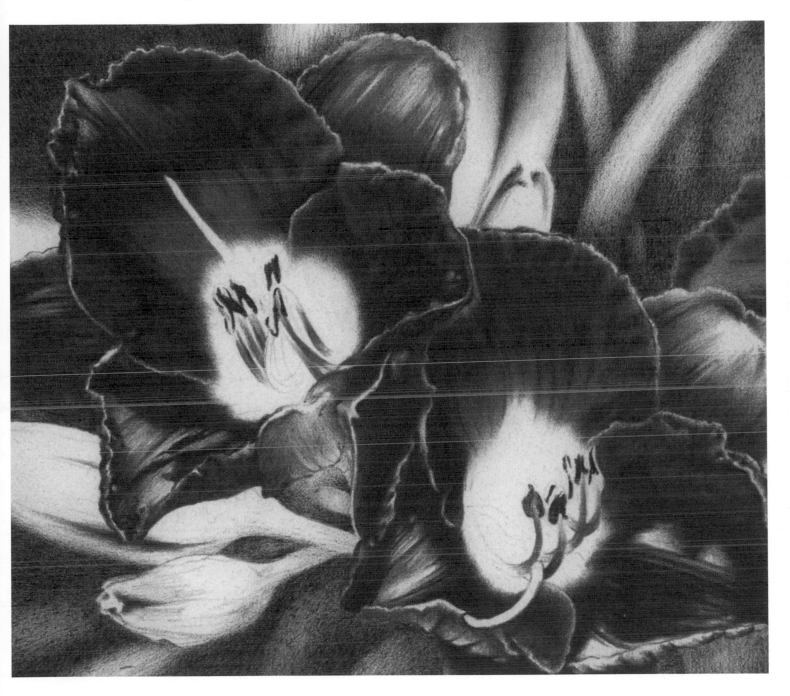

Layer yellow ochre over the flower buds.

Give everything a green cast, and blend with a brush to even out the layers.

Add lime peel to the buds and stems.

Apply marine green to the foliage in the background.

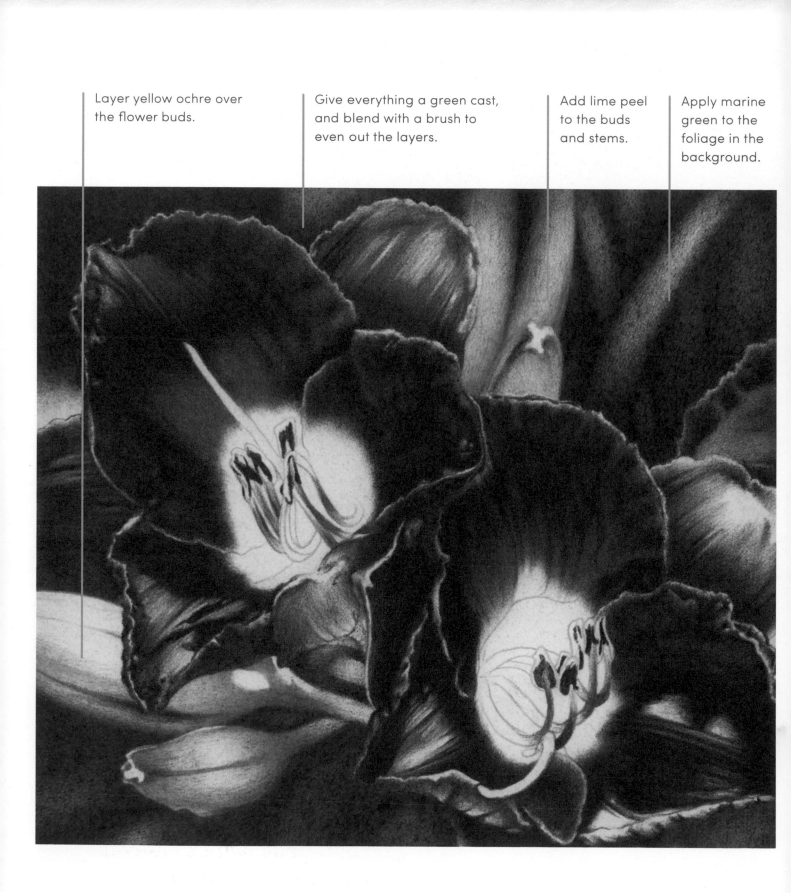

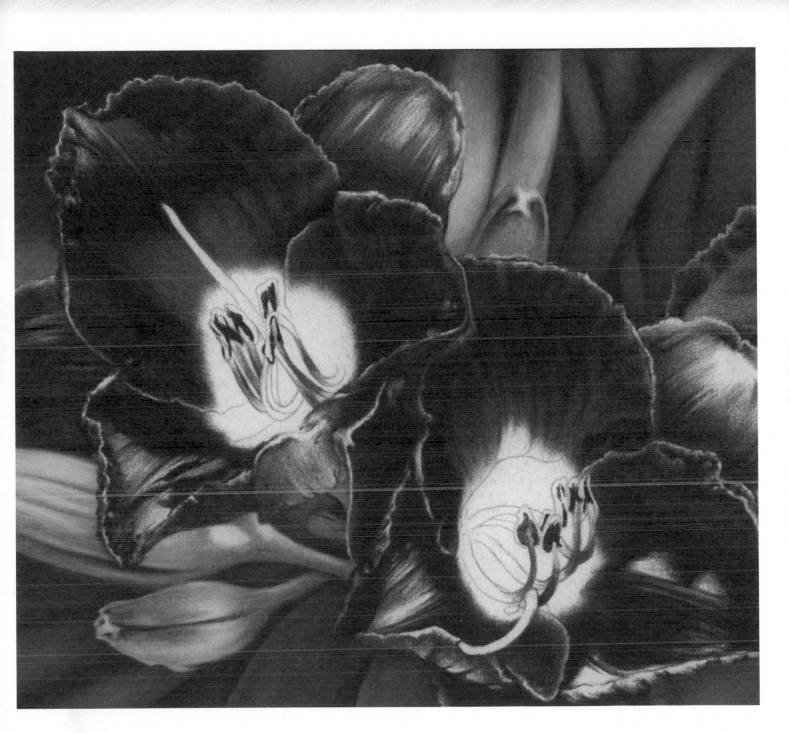

Use kelly green to add depth to the foliage in the background. Lightly apply this color over the leaves wherever they appear closer to the viewer or catch more light.

On the buds, use putty beige and white to lighten the brighter areas and blend the colors that are already in place.

tip

VARY YOUR PRESSURE SO THAT DARKER AREAS APPEAR TO RECEDE, WHILE LIGHTER AREAS LOOK CLOSER.

Now work the flowers' centers by adding canary yellow and lemon yellow. Taper the yellow into the red to create a blended look and also to add a touch of orange where they overlap.

Darken the centers with lime peel and kelly green.

Add yellow to the brighter areas of the stems and leaves.

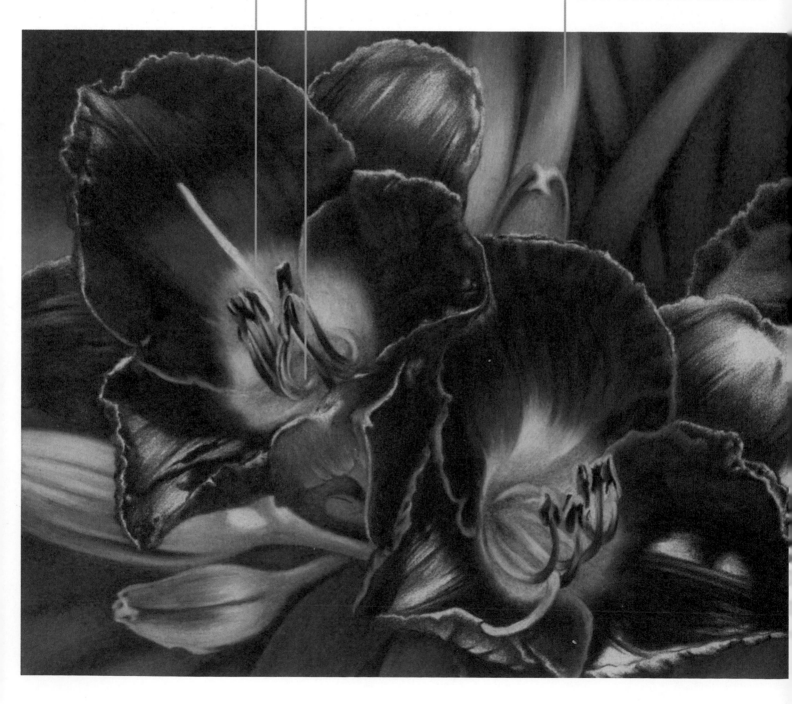

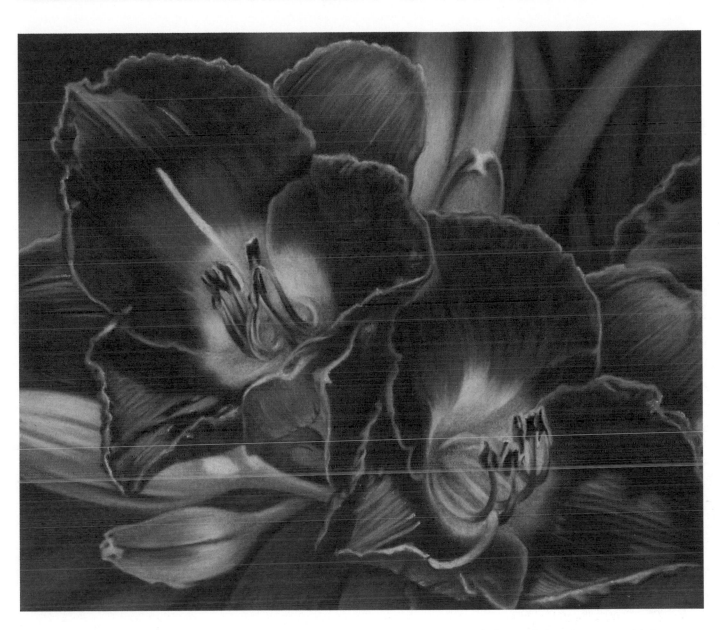

Now move into the areas on the petals that appear to catch the most sunlight and that feature a bluish cast. Blend lilac and ruby red, and use as a highlight color. You can also add white to help blend the colors if necessary.

Darken any recessed areas of the petals using black.

tip

AVOID USING BLACK IN THE FOLIAGE, AS THAT AREA SHOULD FEATURE SOFTER EDGES AND GRADUAL CHANGES IN CONTRAST.

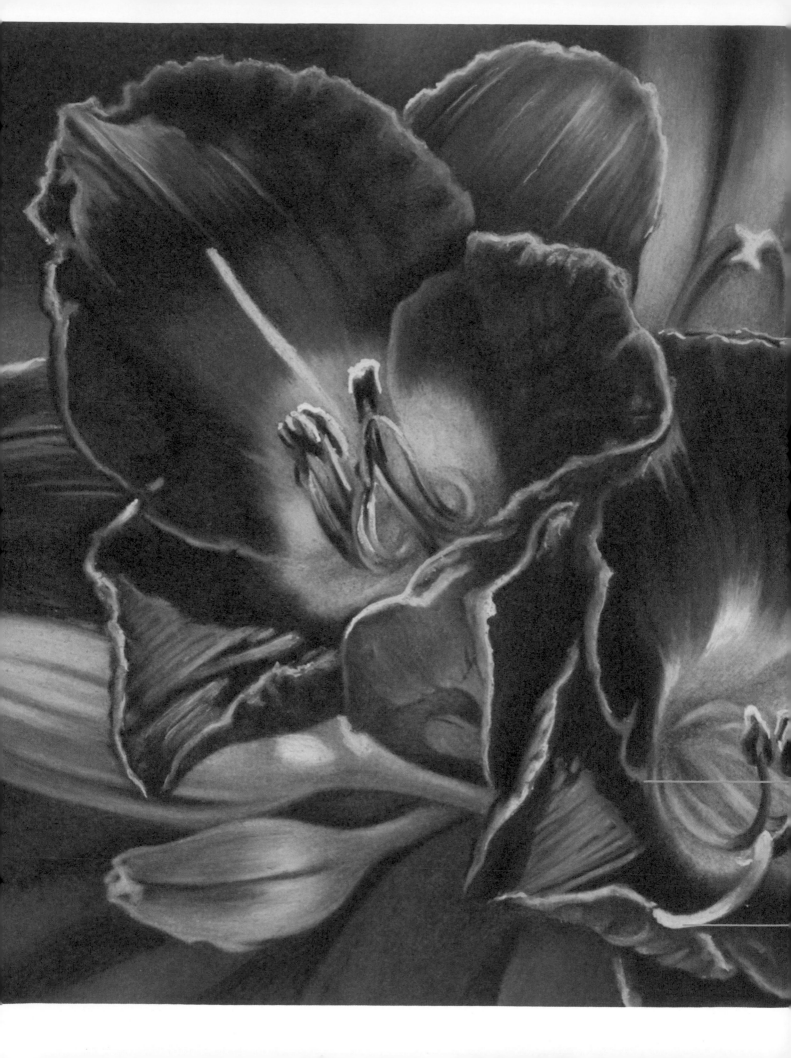

Following the same
idea, add touches of
orange to the foliage.

**A BIT OF COOLNESS ADDS
INTEREST AND VIBRANCY BY
GIVING THE VIEWER'S EYE
A PLACE TO REST AMID THE
WARMER COLORS.**

Add touches of light aqua to the petals; this helps to
break up the large areas of red and purple.

Use white to push the bright spots in the image. First
use the pencil dry, and then dampen it with water and
apply with a small liner brush. Add the damp white
pencil to any area of the drawing that needs to "pop,"
such as the edges of the petals and the stamens.

Layering in a Vibrant Landscape

Look back to the lessons on pages 78-107, and then get started creating your own colored pencil artwork inspired by the images you see here. These steps don't have to be followed exactly; feel free to read through the techniques, and then add your own colors and creative approaches.

Let's start with this lavender field.

First, lay in the shadows.

For softer shadows, use a gray colored pencil.

Use black to create the darkest shadows between the lavender rows and on the chateau.

THE FIRST LAYERS OF NEUTRAL COLORS, SUCH AS GRAYS, GREENS, AND BROWNS, ARE WHAT MAKE THE VIBRANT COLORS IN THE FINAL ARTWORK POSSIBLE.

Place darker blue
in the upper sky.

Form clouds using lighter areas
of colored pencil.

Add gray to the hills to indicate
their different layers.

Apply an even layer on top
of the gray.

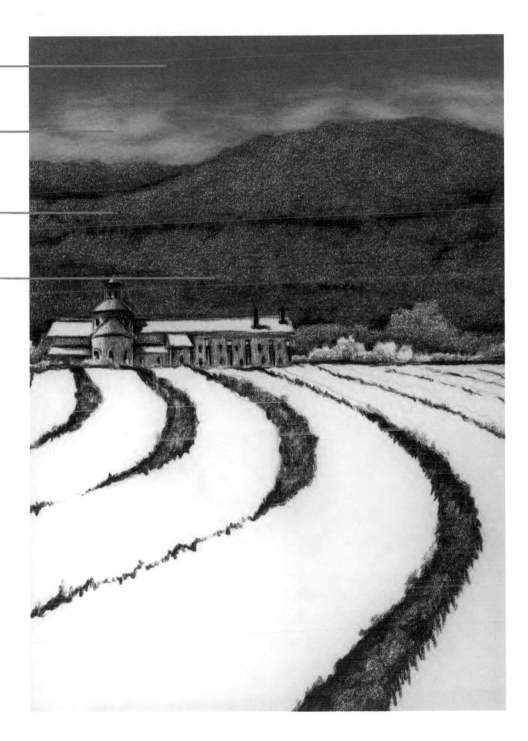

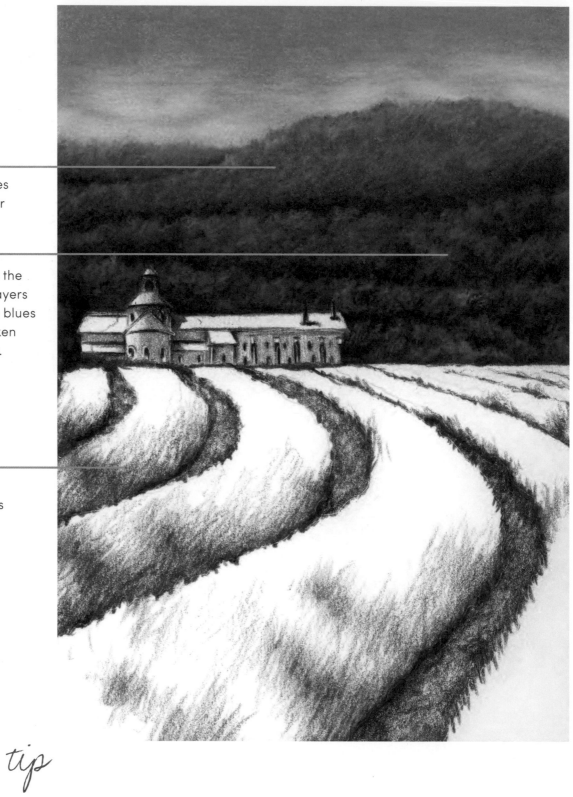

Layer more shades of green over your previous layers.

Add dimension to the hills using more layers of green, and use blues and grays to darken them if necessary.

Use the same greens in the rows of lavender.

tip

USE YOUR PENCIL STROKES TO FOLLOW THE DIRECTION THAT THE LAVENDER WOULD GROW.

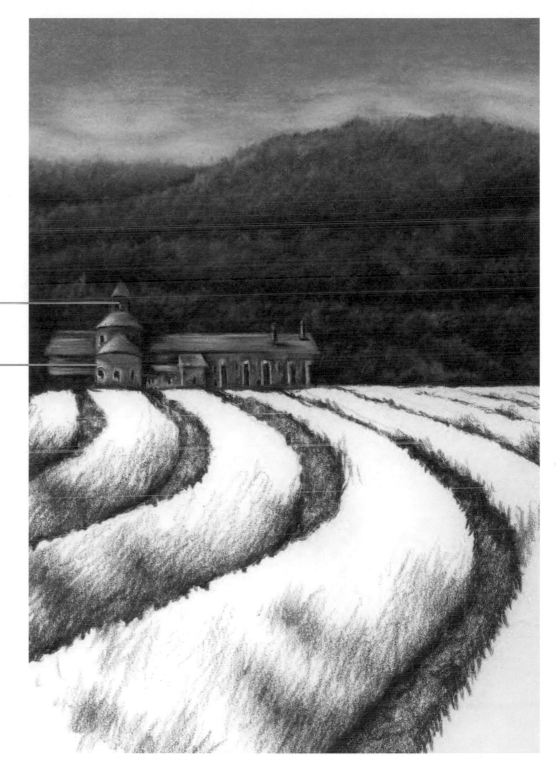

Layer several shades of gray on the building, and glaze color over them.

White punches up the highlights.

USE COLORS LIKE LAVENDER, VIOLET, AQUA, AND PEACH TO GLAZE OVER THE CHATEAU.

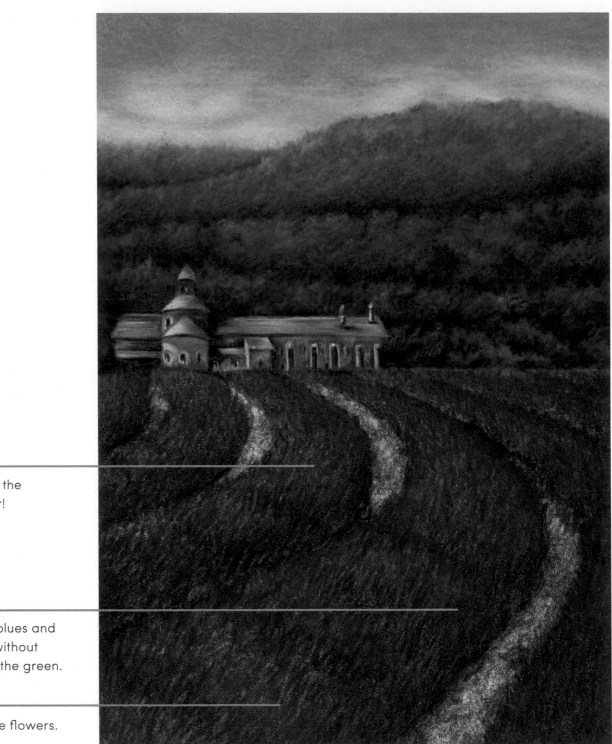

Now add the
real color!

Layer in blues and
purples without
covering the green.

Shade the flowers.

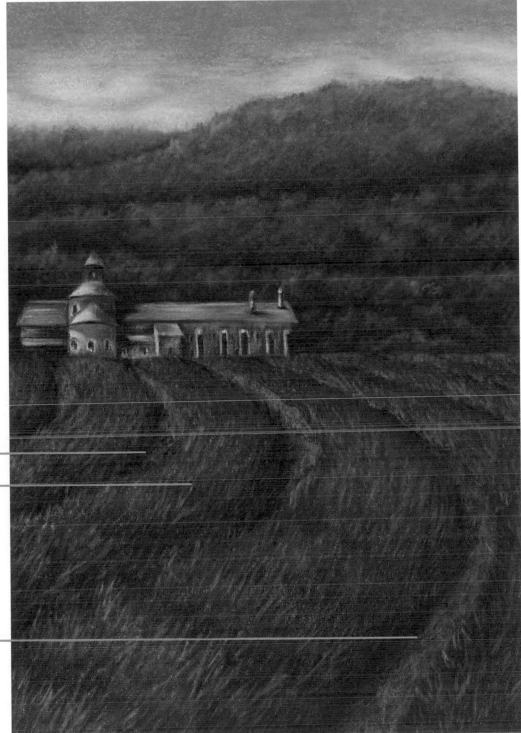

Use black to darken parts of the pathways and indicate shadows.

Adding white to the tops of some of the lavender plants nearest to the viewer implies closeness.

To complete the lavender fields, fill in the pathways with shades of brown.

Placing Focus in a Landscape

When you are drawing a landscape, consider all three planes: the background, the middleground, and the foreground.

First, choose where your subject of focus will go, and then decide how the other planes will support your focus without taking away the viewer's attention.

Sketch the basic outline of your landscape scene.

Start with the lightest colors in the sky.

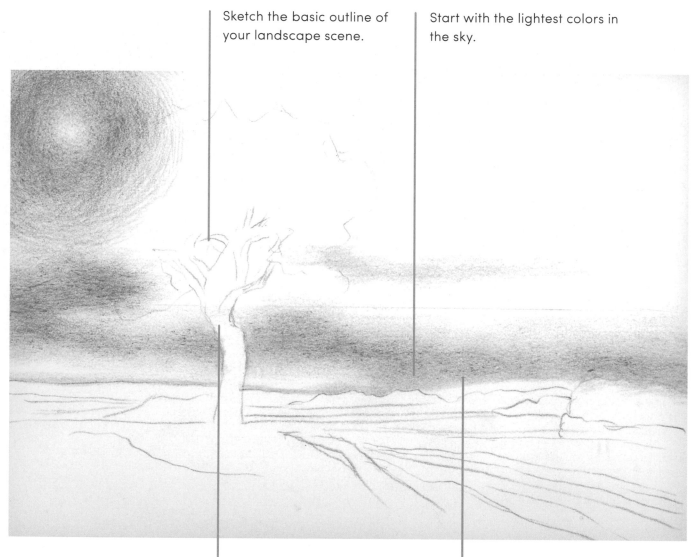

Overlap the tree so the colors will show through the branches in your final drawing.

Use light pressure, and keep your layers as smooth as possible.

tip

KEEP YOUR PENCIL LINES LIGHT SO THEY DON'T SHOW THROUGH IN YOUR FINAL PIECE.

Layer blue over the sky, avoiding the colors that you already added.

Subtly suggest clouds by blending lighter colors into the darker ones.

Aim for smooth applications of each color.

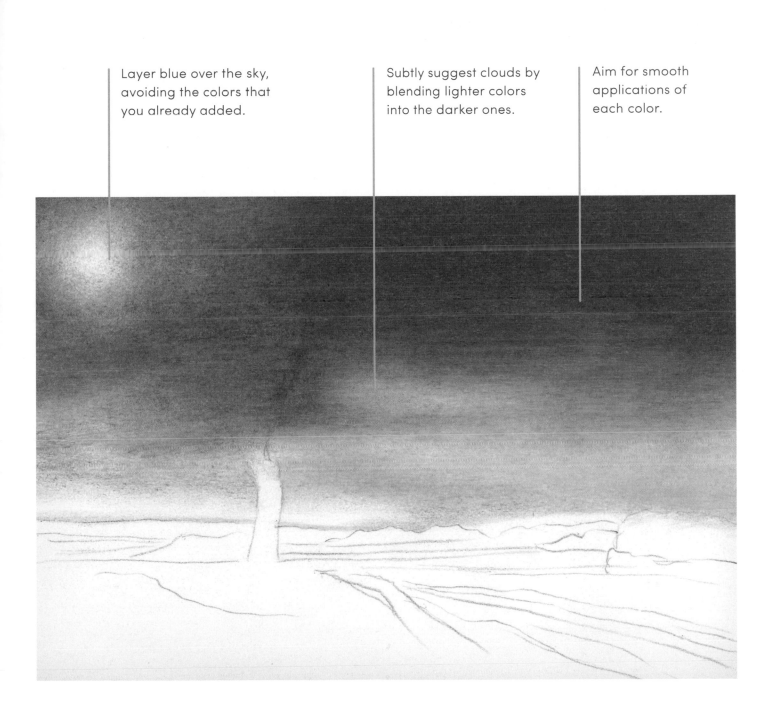

tip

BUILD UP LIGHT LAYERS WITH SOFT EDGES TO MIMIC THE SMOOTH GRADATIONS OF NATURE.

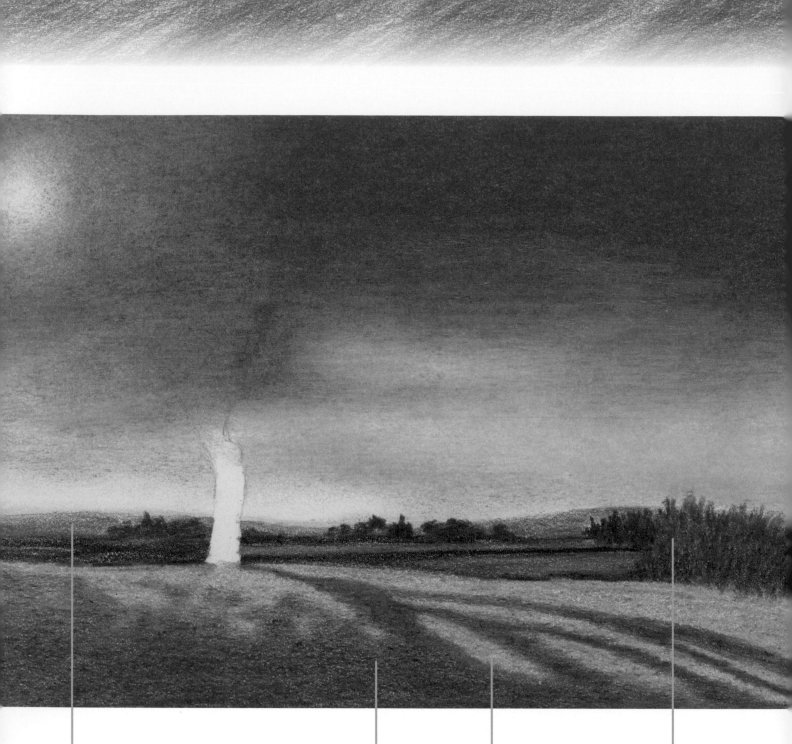

Start with the distant hills, and layer colors to create a realistic look.

Then apply colors to the foreground.

Use a darker color to define the cast shadow pattern of the tree branches.

To develop the shrub, stroke vertically in the direction of leaf growth for a realistic touch. Use the same technique to build the grass.

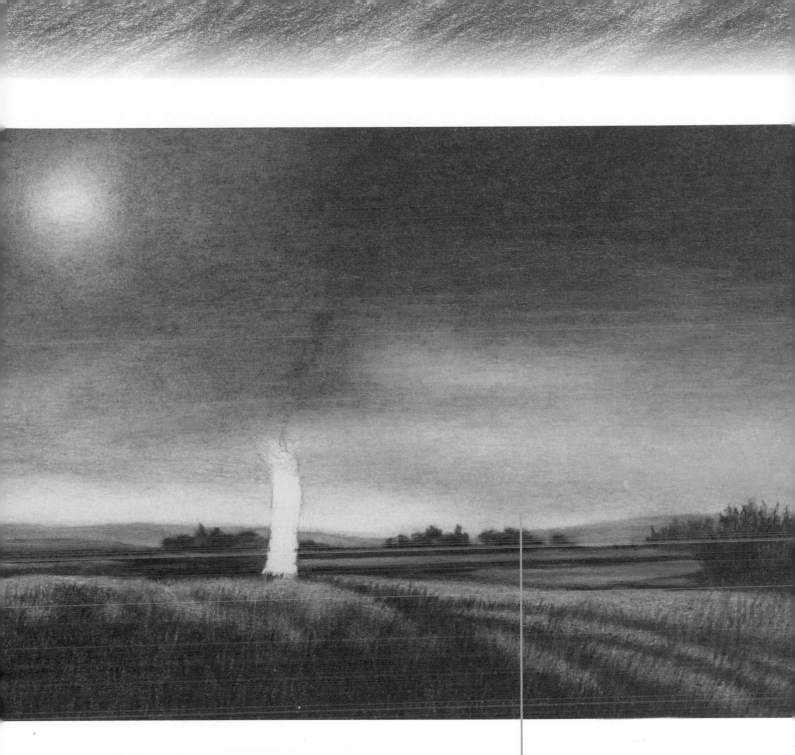

Layer light colors in the distance to create
the misty illusion of atmosphere.

tip

**TO ENHANCE THE EFFECT OF ATMOSPHERIC PERSPECTIVE,
KEEP FOREGROUND DETAILS SHARP AND COLORS BOLD.**

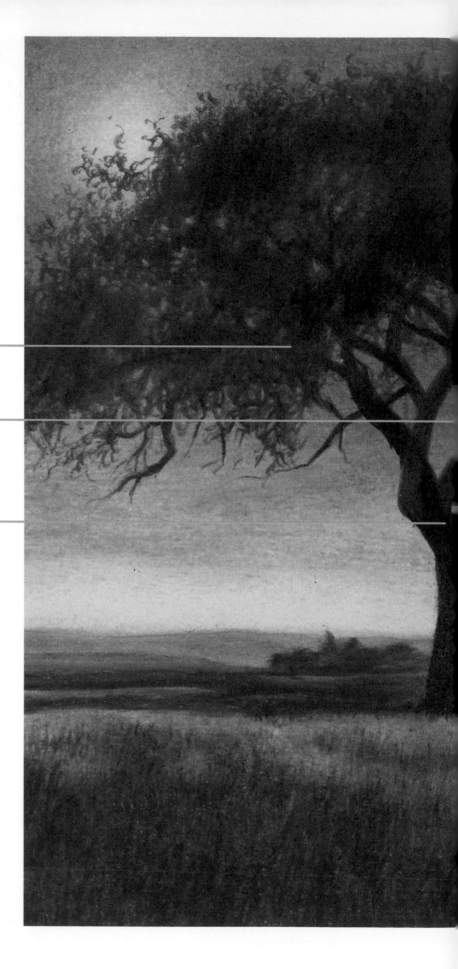

Draw any shapes you like in the tree.

Make some areas of the tree completely dark, and let others remain open and airy to suggest leaves.

Use black to darken some areas of the tree branches and trunk.

tip

USE LONGER, DARKER STROKES TO DEFINE THE TREE'S LIMBS AND SHORTER, LIGHTER STROKES FOR ITS LEAVES. YOU'LL USE THE SAME PENCIL TO DEFINE THE TWO ELEMENTS OF THE TREE, SO IT'S IMPORTANT TO DISTINGUISH THEM BY CREATING DIFFERENT TEXTURES.

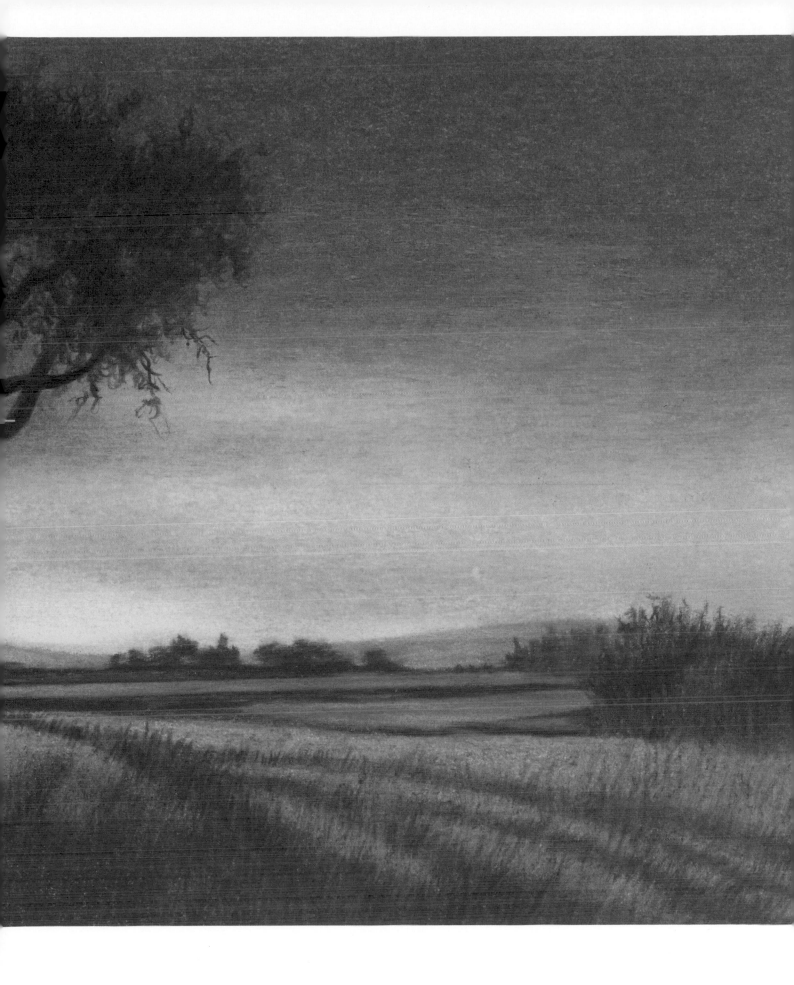

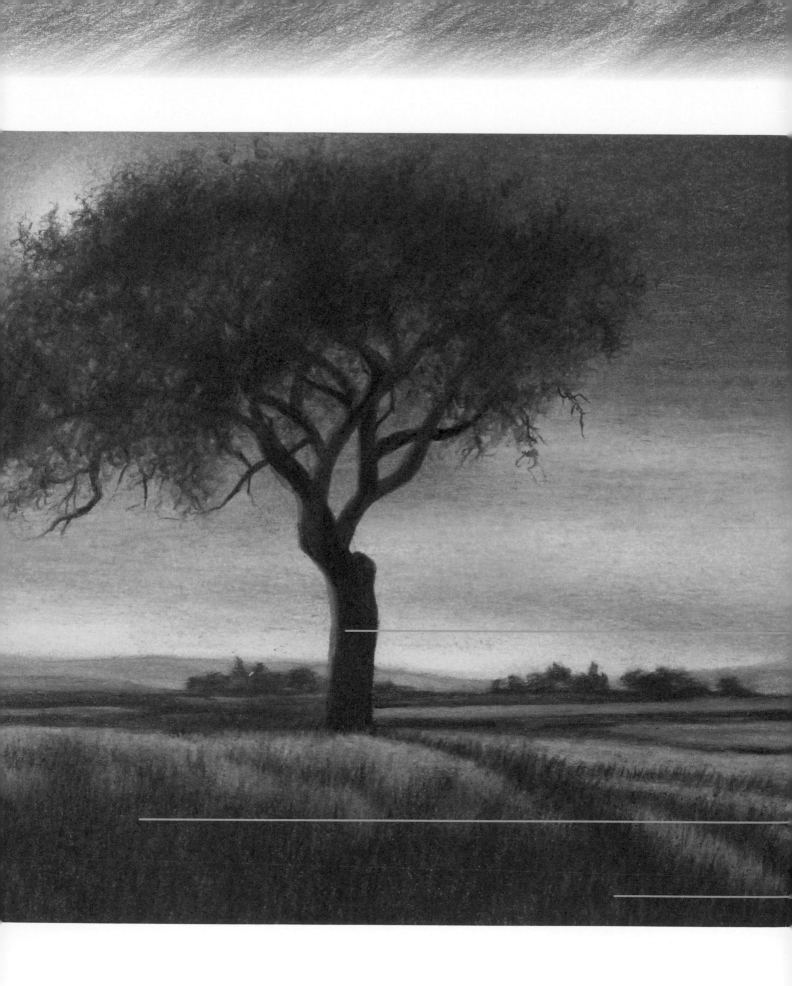

tip

WHEN WORKING ON A LANDSCAPE, START WITH THE MOST DISTANT AREAS, AND WORK YOUR WAY FORWARD. THIS HELPS MAINTAIN A SENSE OF SPACE AND DEPTH.

Focus on accenting with more intense colors.

Make sure not to completely cover the neutral grays and greens.

Liven up the shadows in the tree and grass.

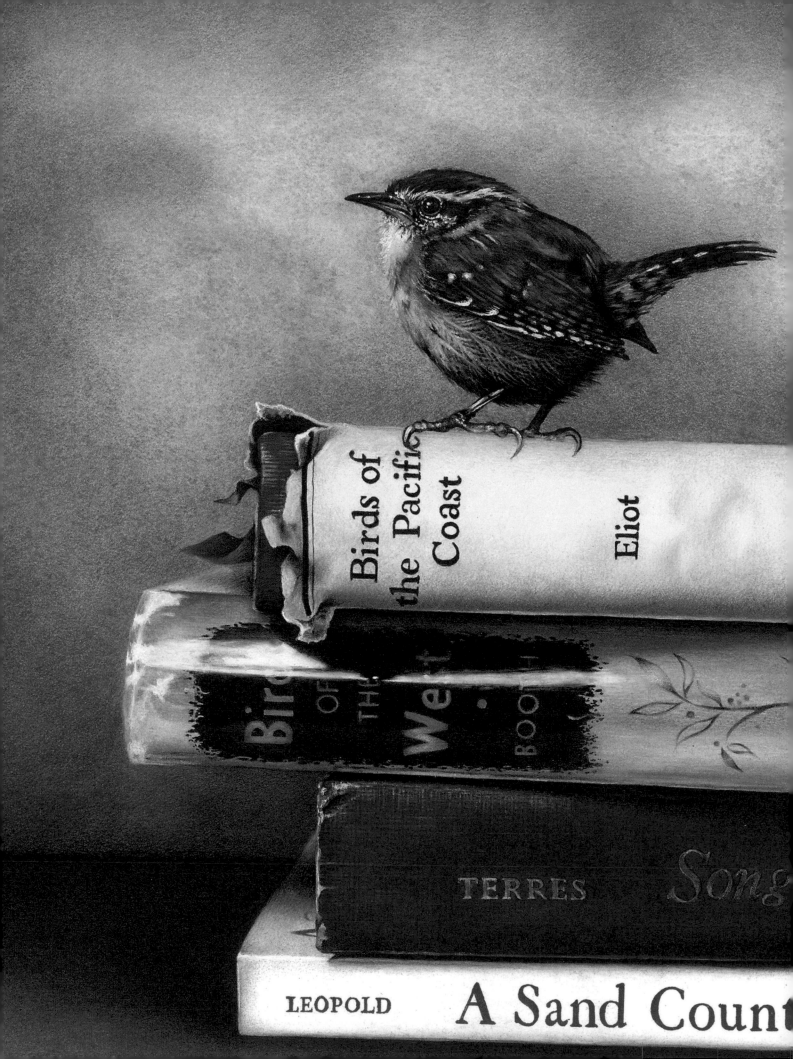

Birds of
the Pacific
Coast

Eliot

Bir_ of the We_t
B___

TERRES Song

LEOPOLD A Sand Count

What's NEXT?

Continuing Your Artistic Education

Now that you've familiarized yourself with drawing with colored pencils, there's no better time to continue your artistic education than right away! But how can you do that? Read on to learn more about continuing your art training, working with other artists, and experimenting on your own. And don't forget to practice any chance you get!

MAKE SWATCHES

Practice makes perfect, and a great method for continuing your journey with colored pencils is by creating swatches. You can create mixes of color to use for future reference or to catalog and familiarize yourself with your pencils.

EXPERIMENT WITH SUBJECT MATTER

Choosing to draw a wide range of subjects will allow you to explore all the different textures that you can achieve with colored pencils. It will also give you an opportunity to play with genres, such as landscapes, portraits, and abstracts.

CREATING SWATCHES HELPS YOU PRACTICE SMOOTHLY LAYING DOWN YOUR PENCIL STROKES.

EXPLORE WHAT'S POSSIBLE

The chameleon-like colored pencil can mimic many other mediums, such as paint and photography. Each colored-pencil artist also imparts his or her own style to the medium, resulting in a wide array of looks that can be achieved using a single tool. Explore what's possible and see what other colored pencil artists are doing. Visit the Colored Pencil Society of America's website at www.cpsa.org, and be inspired by the possibilities.

JOIN AN ART GROUP

Sharing ideas with like-minded people is a terrific way to learn and get motivated. Consider joining an art league, critique group, or colored-pencil group that already exists in your area. If you can't find one, think about organizing one using word of mouth or the Internet. Groups like this typically meet once a month or every other month and allow you to share techniques, problem solve, and invigorate your artistic side.

CREATING ART WITH A GOAL IN MIND IS A GREAT WAY TO STAY MOTIVATED AND INSPIRED.

ENTER A SHOW

Once you have a few drawings under your belt, consider entering a show or contest. Enter a colored-pencil show, or look for another local or regional show that interests you. Many art galleries host annual contests, and online shows are prevalent as well.

TAKE A WORKSHOP

Think about increasing your skills by attending a workshop taught by a colored-pencil artist whom you admire. Many colored-pencil artists teach classes throughout the year, so take advantage of these, and learn some new tricks. If you're a member of an art group, you can suggest that your group host a workshop taught by an artist so that all members can attend and help offset the costs.

You may also want to take a vacation centered around drawing with colored pencils. There are even cruises that offer colored-pencil classes while on board! Do some research online to find the best options for your schedule and style.

BUILD YOUR DRAWING SKILLS

It never hurts to strengthen your drawing skills, especially if you're an aspiring colored-pencil artist, and there are many ways to do this on your own.

- Carry a sketchbook with you, and use it!
- Build up a library of drawing books.
- Visit galleries and museums, study works that appeal to you, and copy drawings created by the old masters.

PLAY WITH MIXED MEDIA

Many art mediums work well when mixed with colored pencil, and mixing media can even highlight the unique traits of each medium. Try using watercolor or ink as a base for colored pencil, or consider using pastel, acrylics, collage, or graphite pencil in combination with colored pencil. The possibilities are endless, and learning through experimentation is invaluable. For more on mixed media, see page 68.

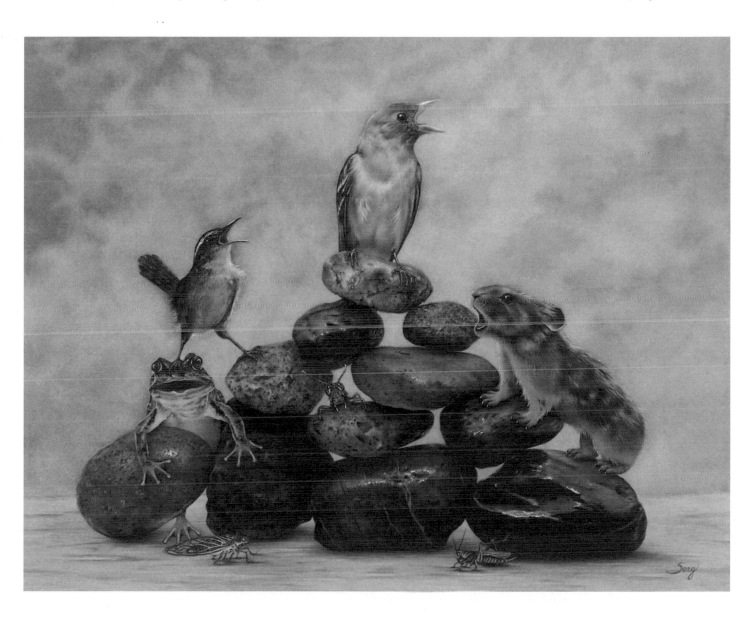

SPENDING JUST 20 MINUTES A DAY DRAWING WILL IMPROVE YOUR SKILLS OVER TIME, SO DRAW, DRAW, DRAW!

About the Author

Eileen Sorg began working with colored pencil during the late 1990s and over time has developed her own signature style. With a degree in wildlife science from the University of Washington and subsequent time spent studying birds and mammals as a biologist, Eileen brings a bit of science to her artwork and how she sees the world. This structured training is now combined with her unique sense of humor to produce the highly narrative and whimsical work for which she is known.

Eileen is a signature member of the Colored Pencil Society of America and a member of the Women Painters of Washington. Her work has been featured in *The Artist's Magazine*, *American Artist*, *Southwest Art*, *and Drawing Magazine*. A highly sought-after instructor, Eileen teaches across the United States and Canada. Her work has been obtained by museums and can be found in both private and public collections throughout the world.

Eileen lives with her husband, Scott Anderson, and their many horses and dogs on their farm in Kingston, Washington.

For Scott. And Scout. Always.